The Thirteen Stone Codex

By Israel F. Haros Lopez

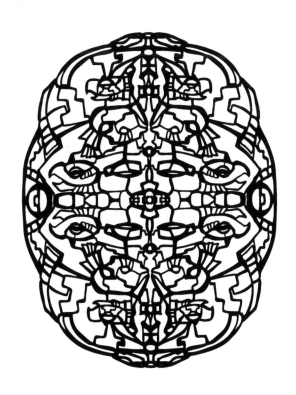

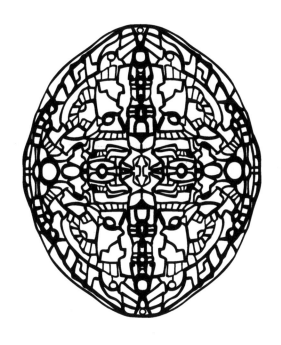

Thirteen Stone Codex
Illustrated by Israel F. Haros Lopez

Cover Design by Israel F. Haros Lopez

Thirteen Stone Codex
Copyright @ 2016 by Israel F. Haros Lopez
All Rights Reserved . First Edition
Waterhummingbirdhouse Press

Contact author at
waterhummingbirdhouse@gmail.com

First Edition by Waterhummingbirdhouse Press 2016

Library of Congress Cataloguing in Publication Data available upon request

ISBN-13:
978-1534995031

ISBN-10:
153499503X

The Thirteen Stone Codex

Is dedicated to the first stone carved. To first fire built. To the first song uttered. To the first breath. To the first circle drawn, carved, gathered, held. To all our ancestors that protected what they learned and etched it on a wall. Wrote it on a paper. This codex is dedicated to all the first prayers. The ones our ancestors made thousands and thousands and thousands of years ago, so that we could be here. Alive and well and healthy. To the first song to water. To the first song to life. To the first time we gathered to help each other. To the first time we looked up and saw all the maps held in the stars. To the first instrument. To the first gathering.

Israel

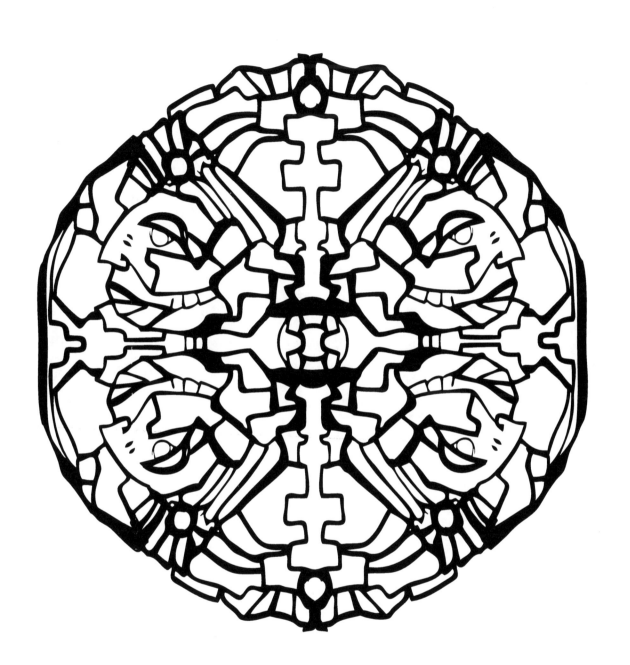

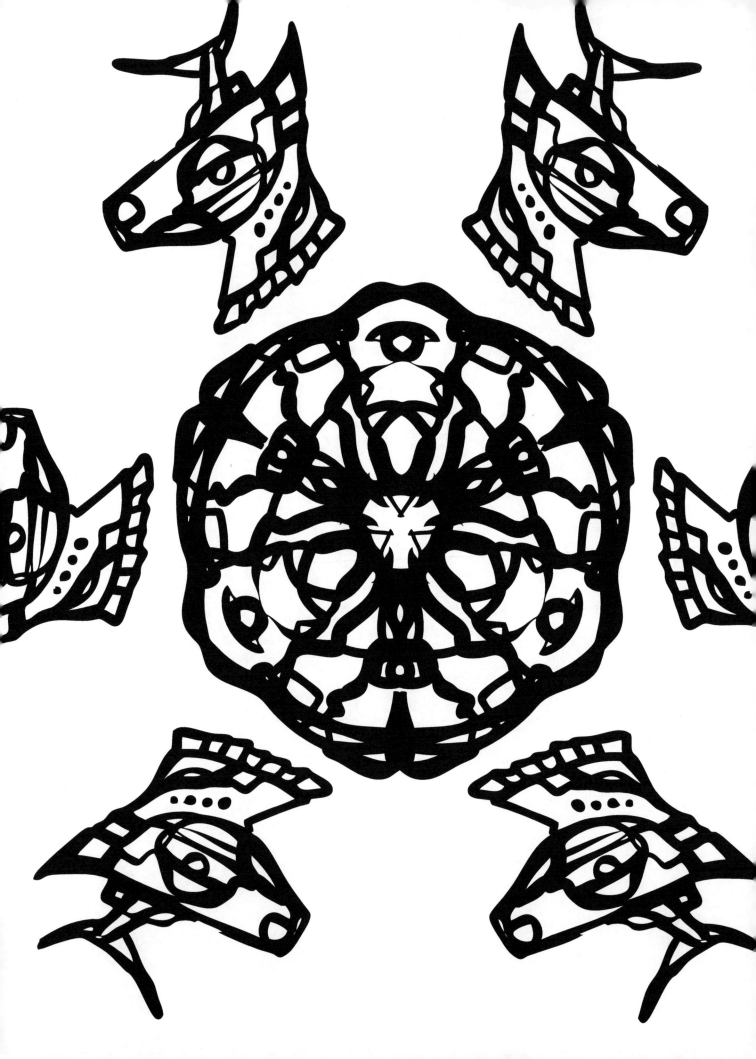

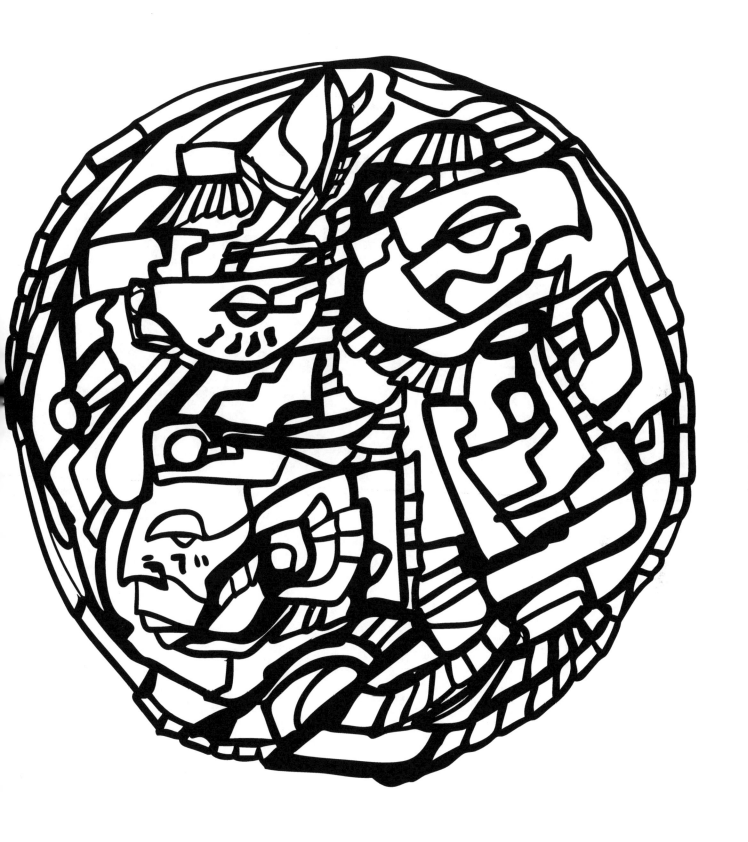

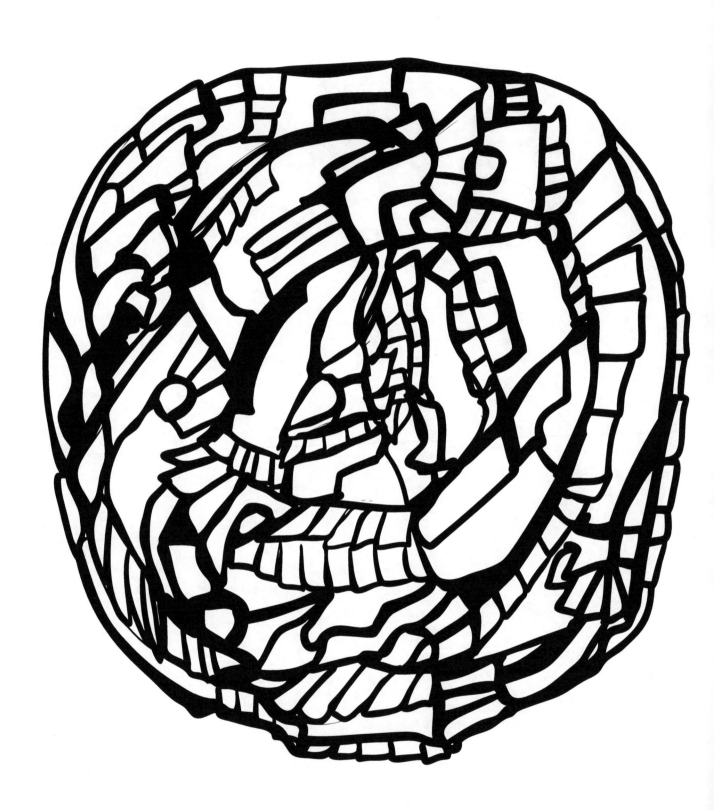

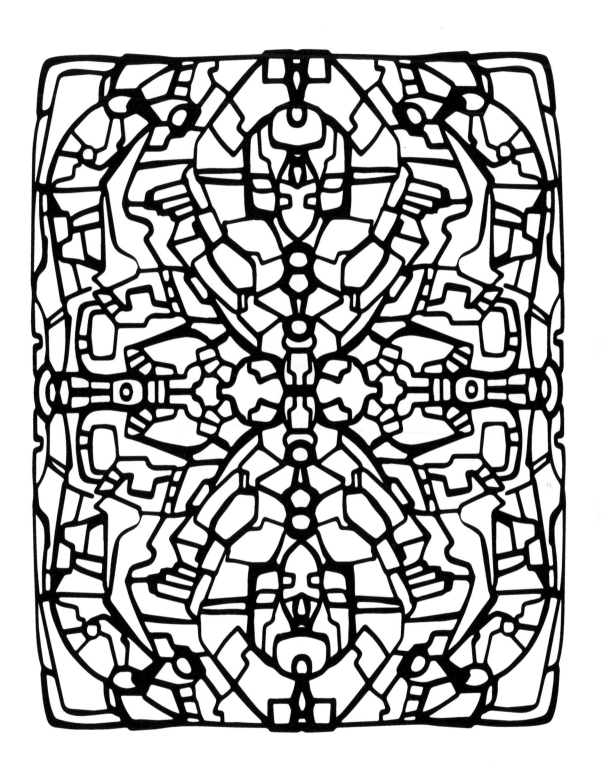

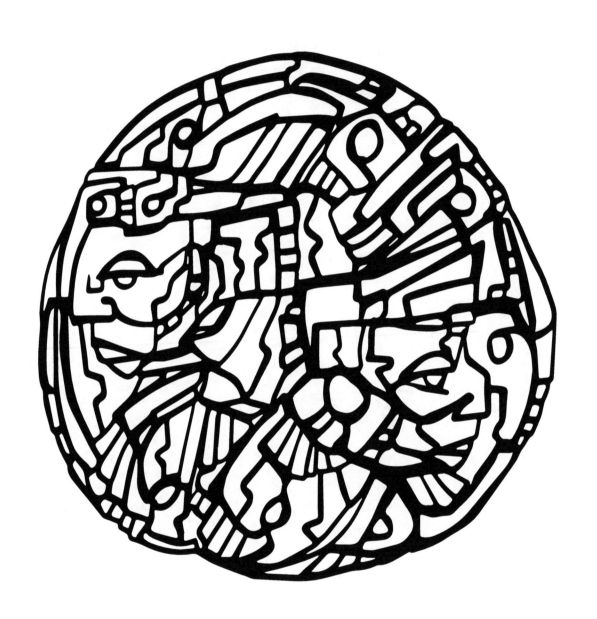

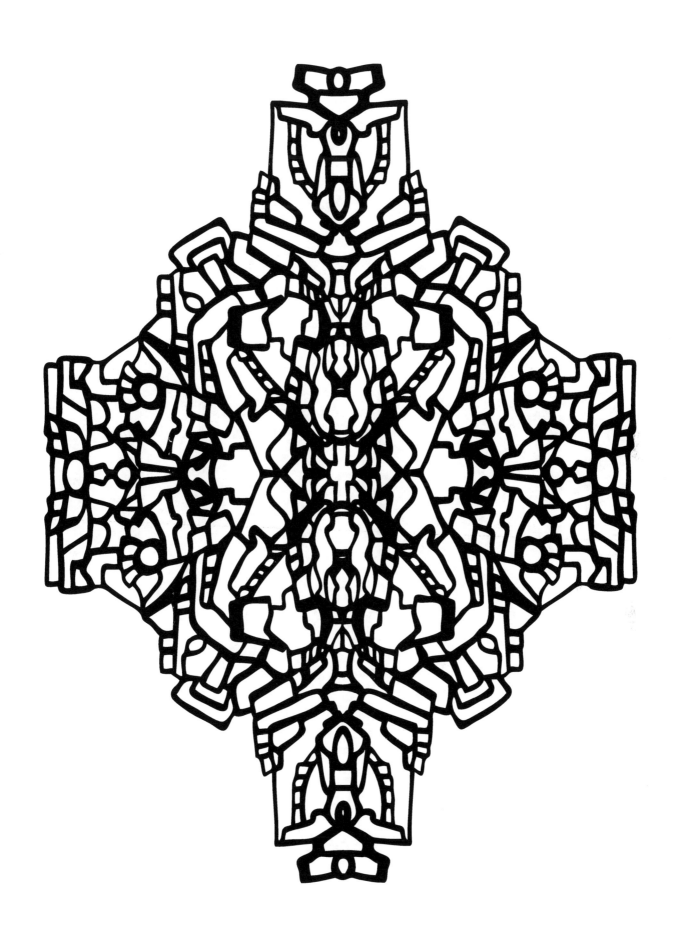

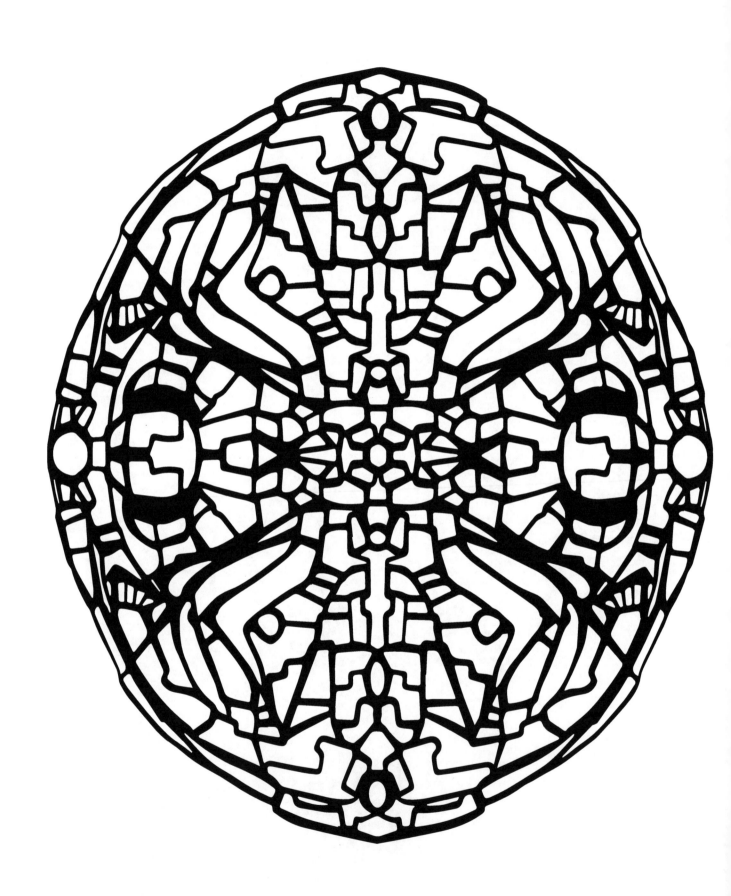

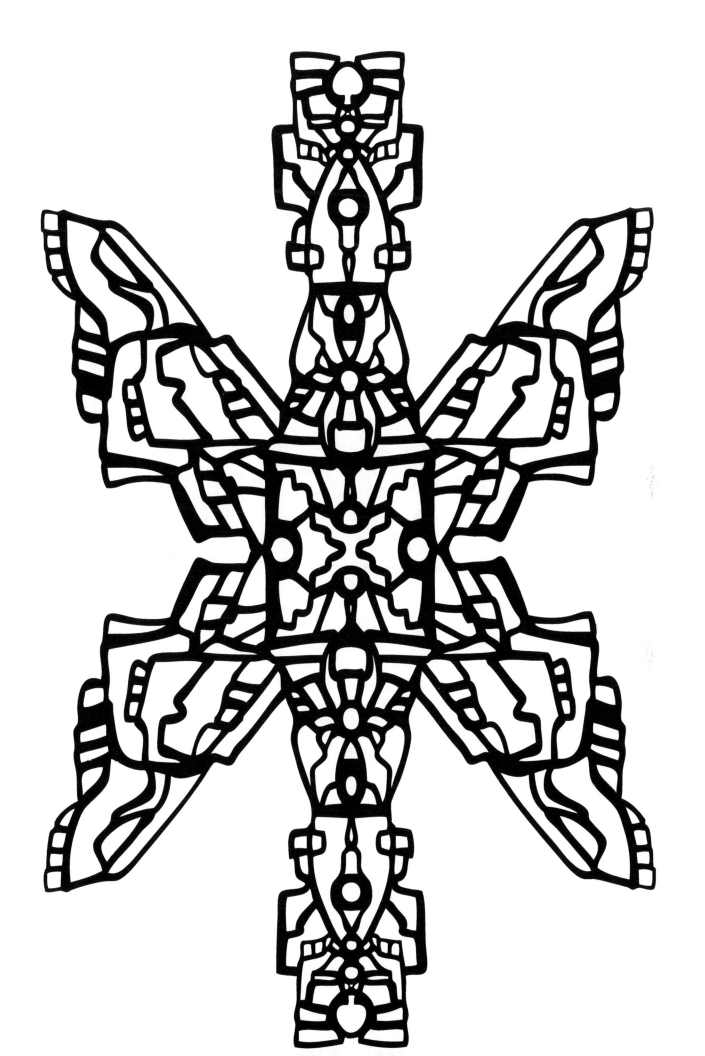

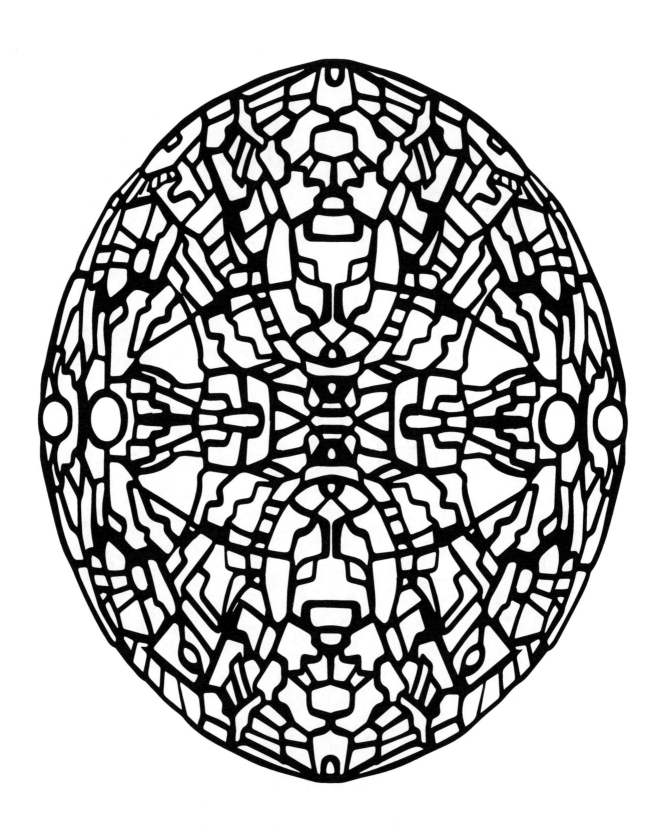

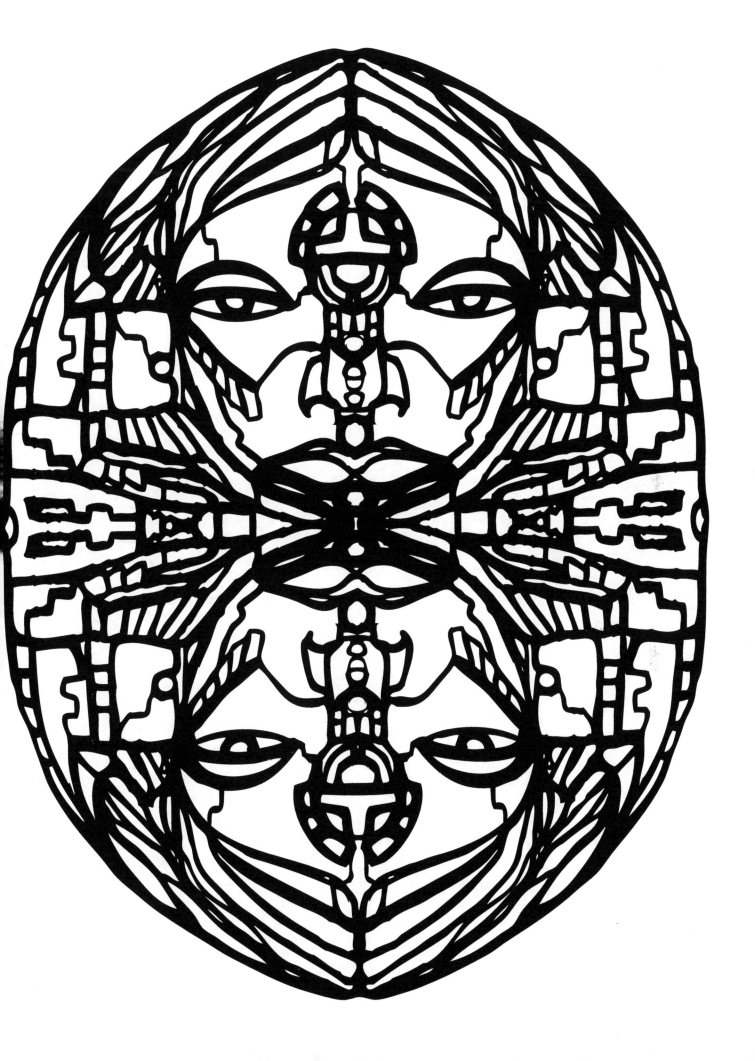

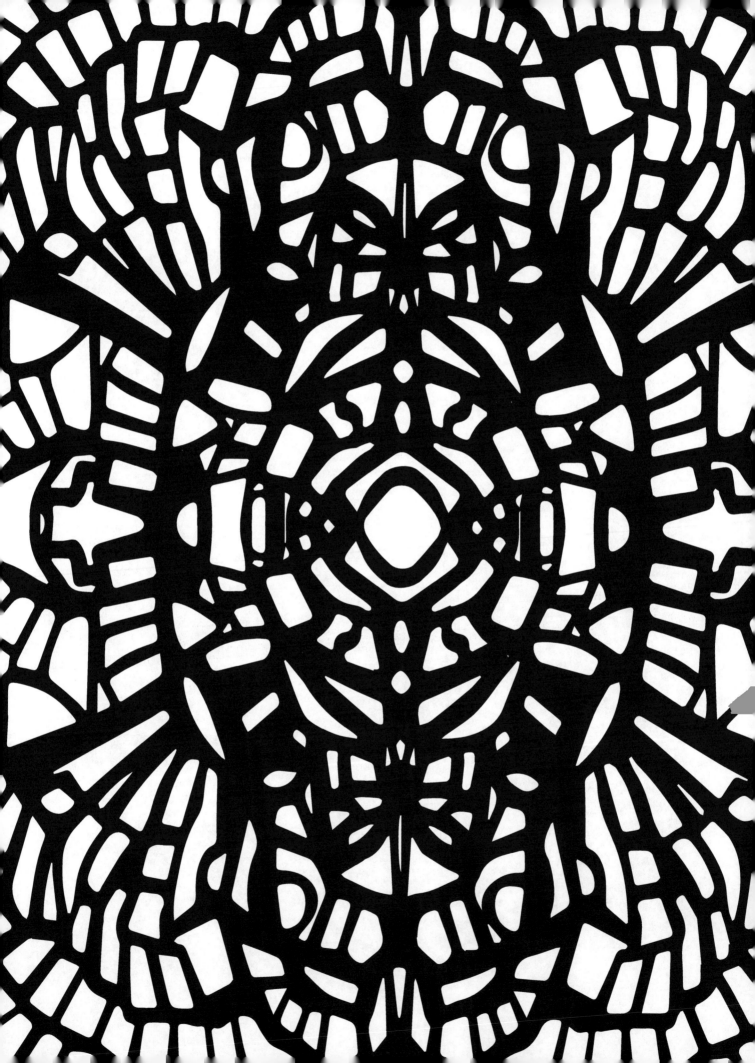

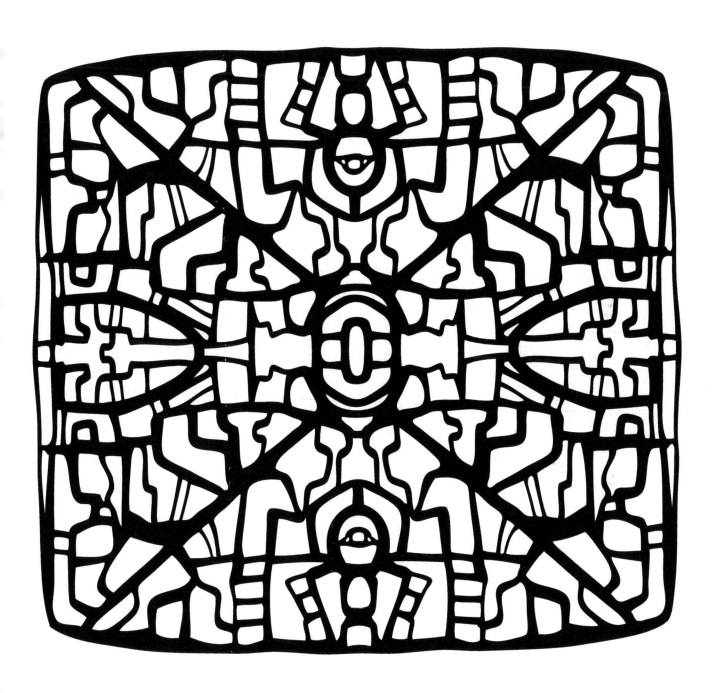

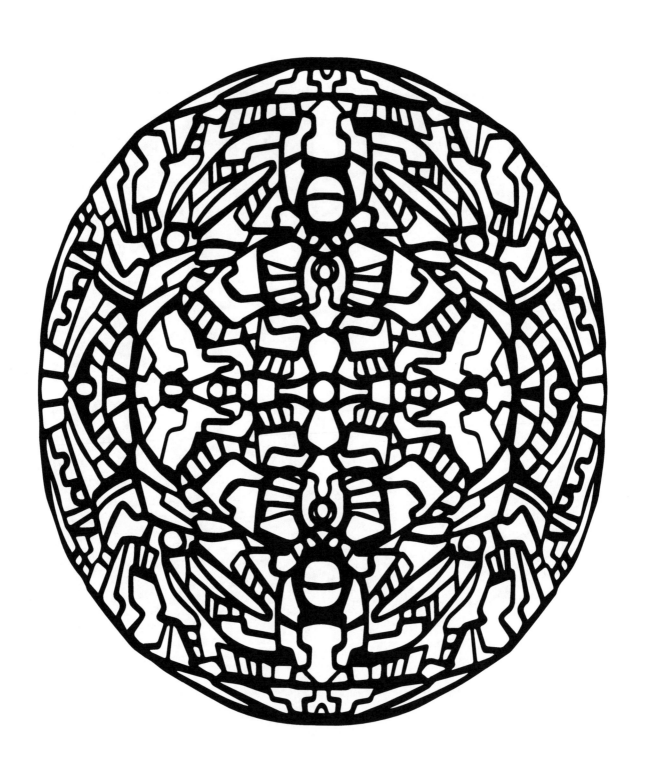

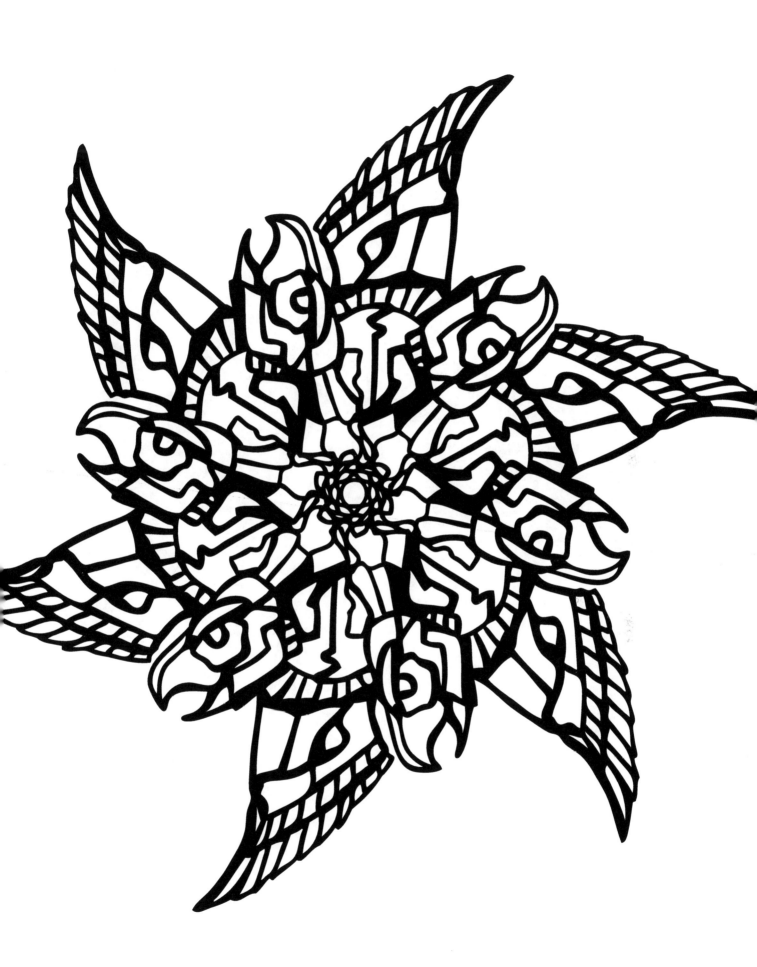

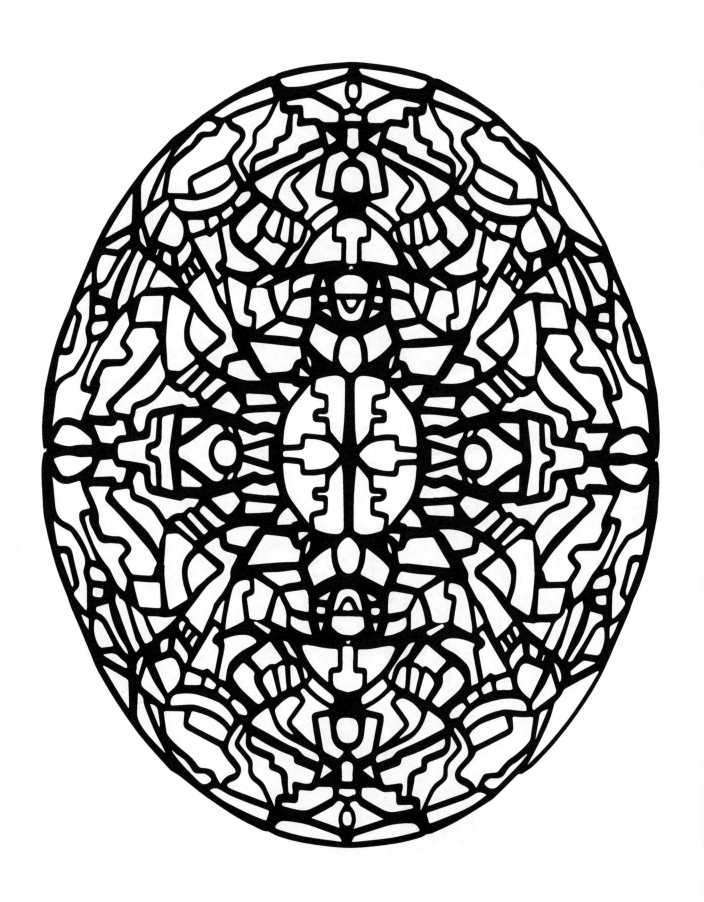

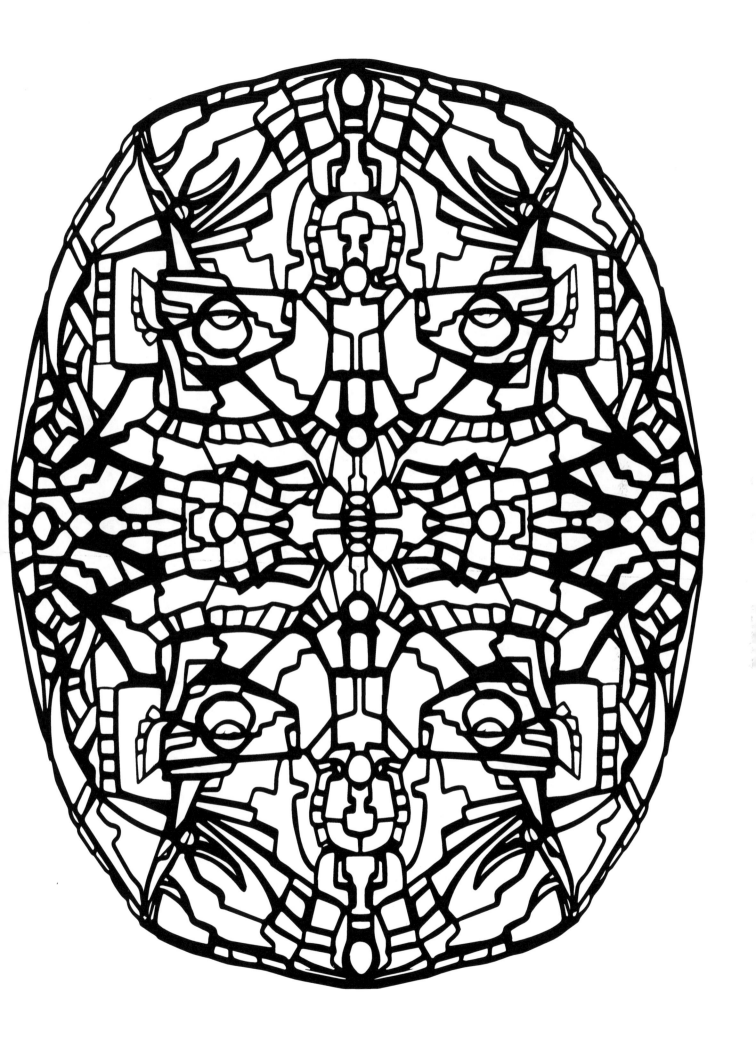

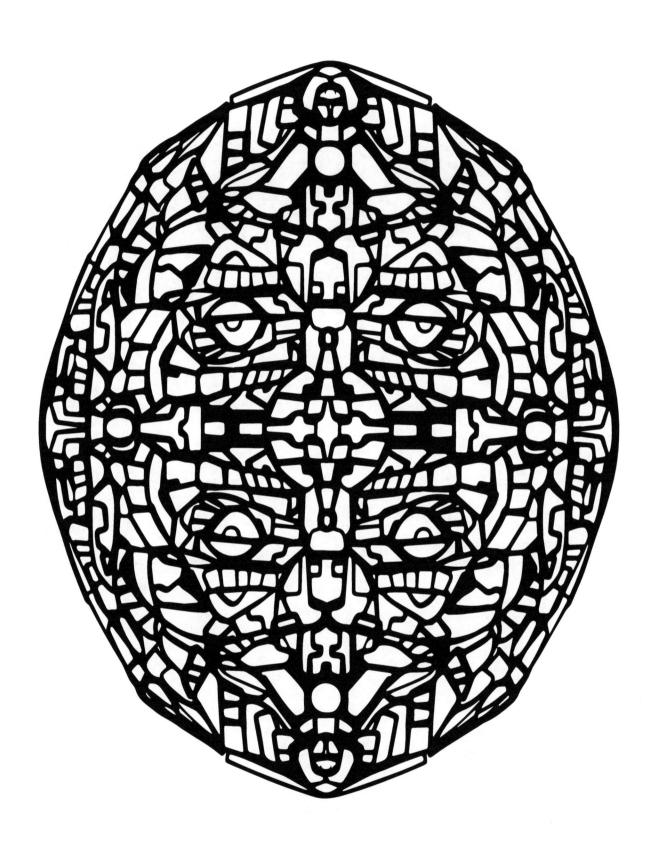

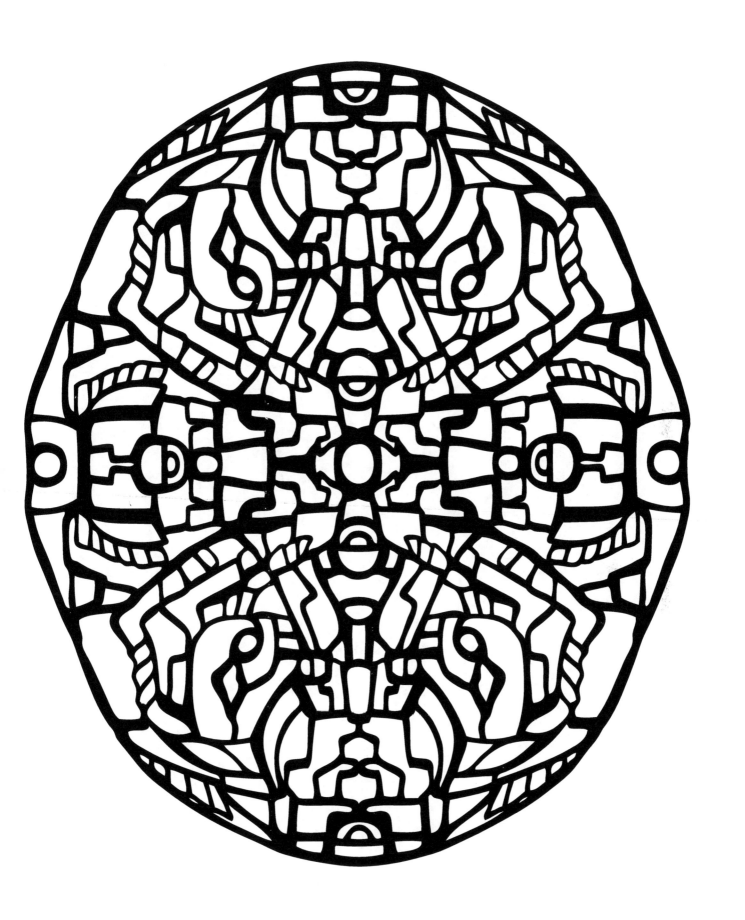

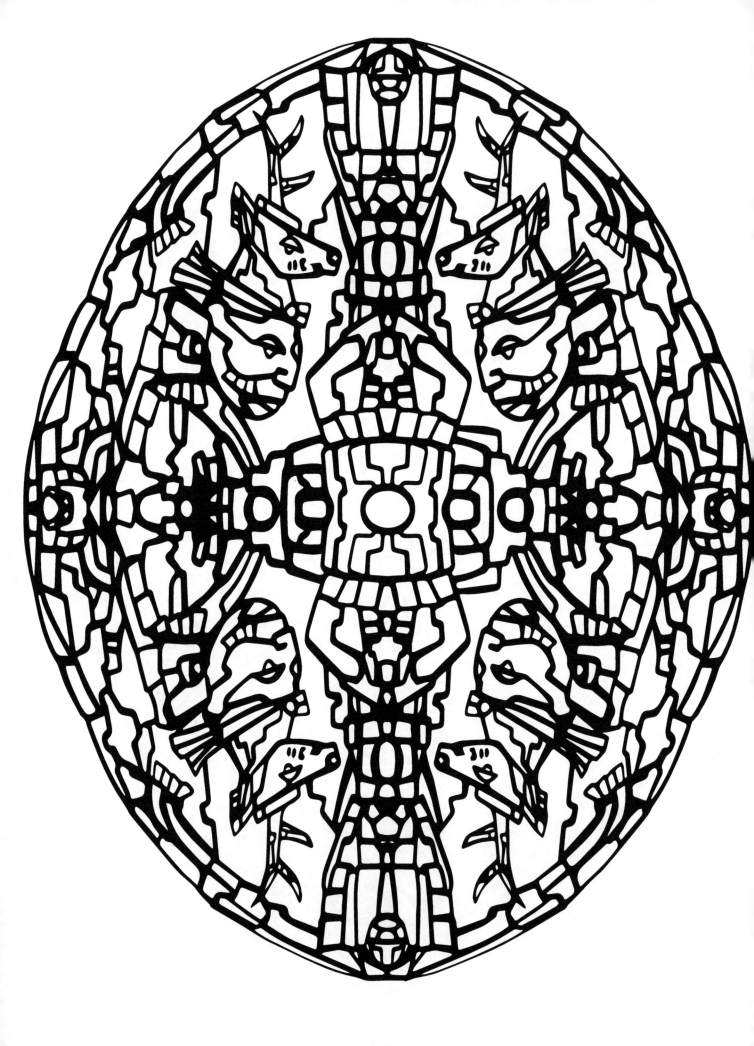

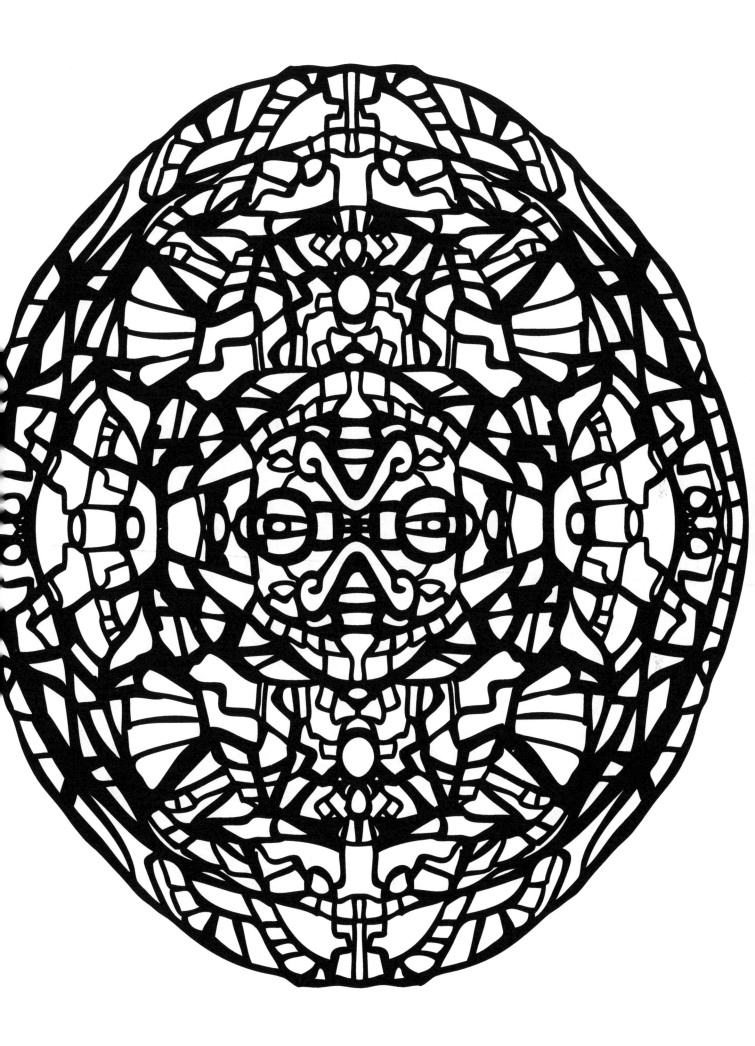

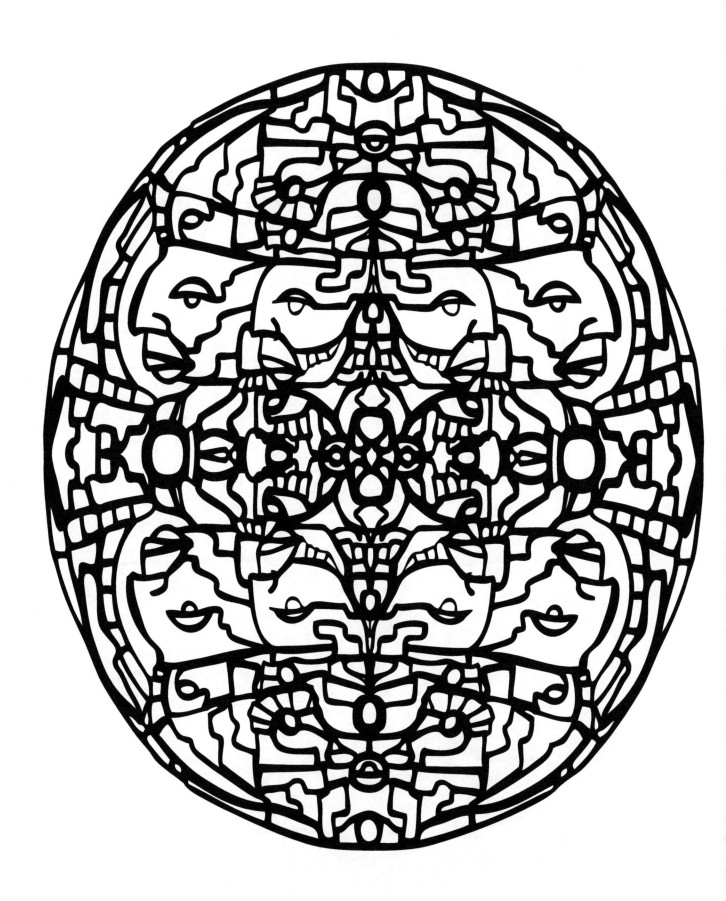

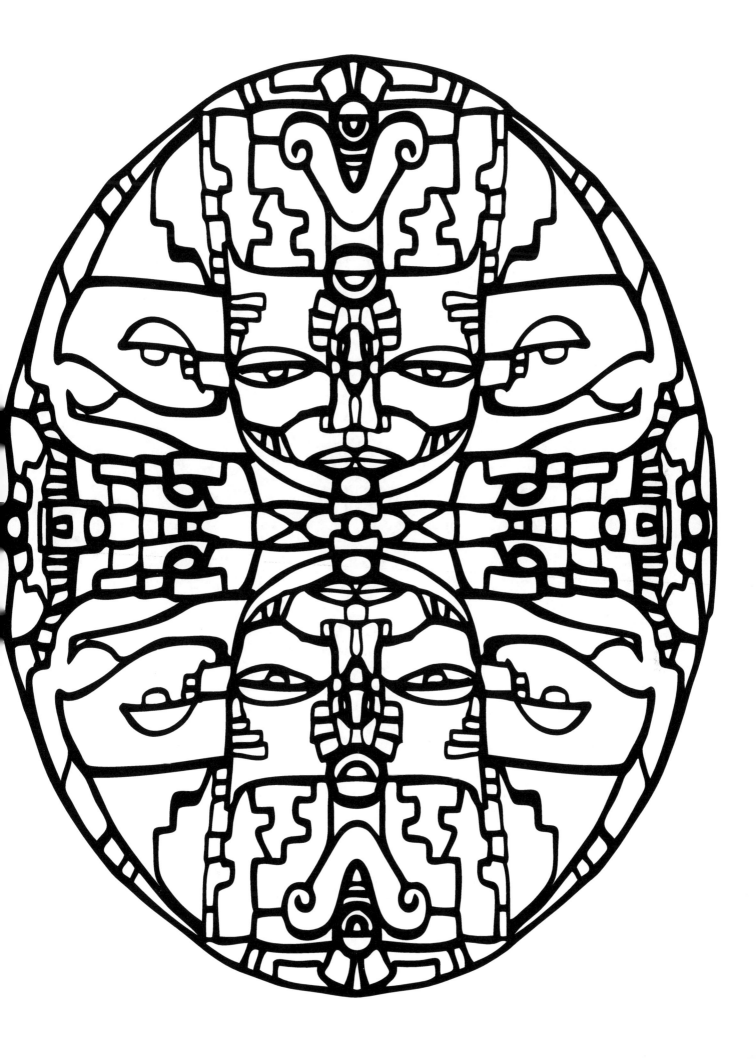

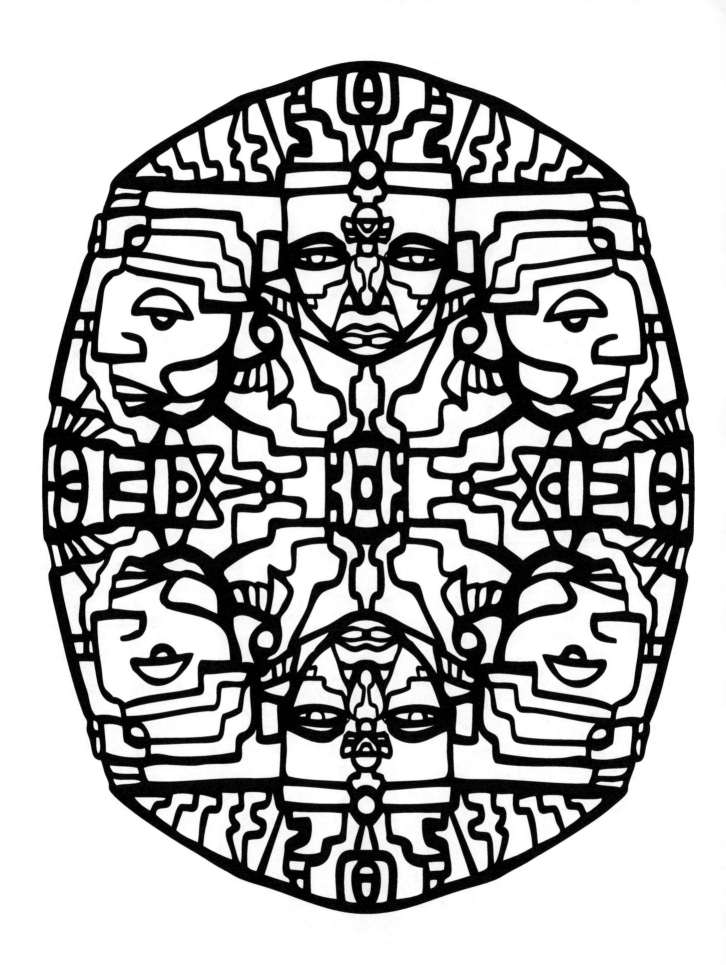

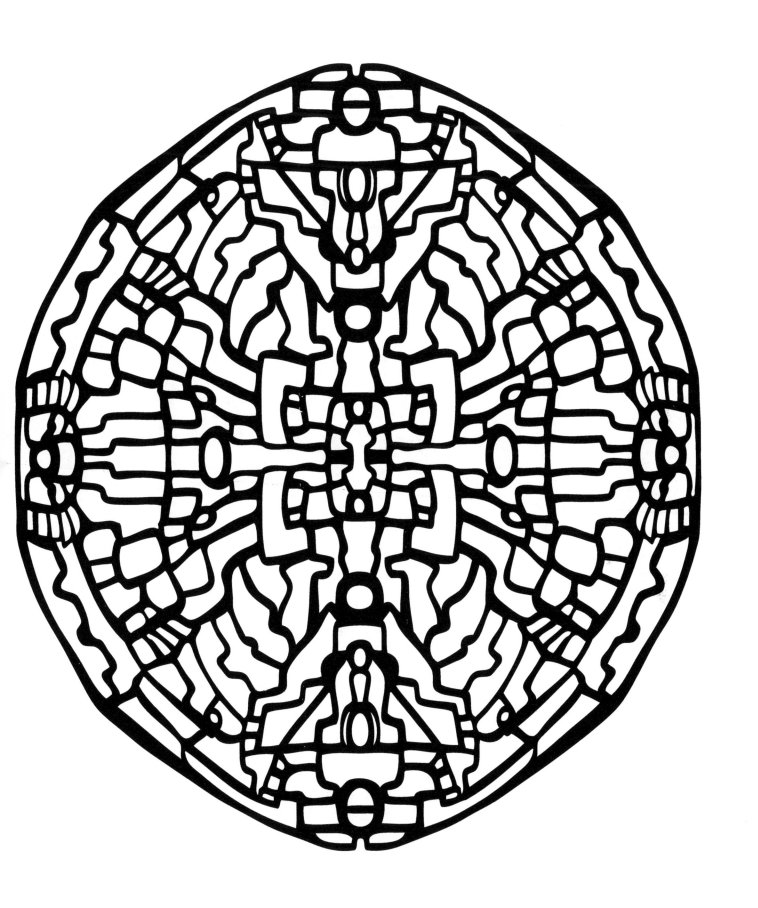

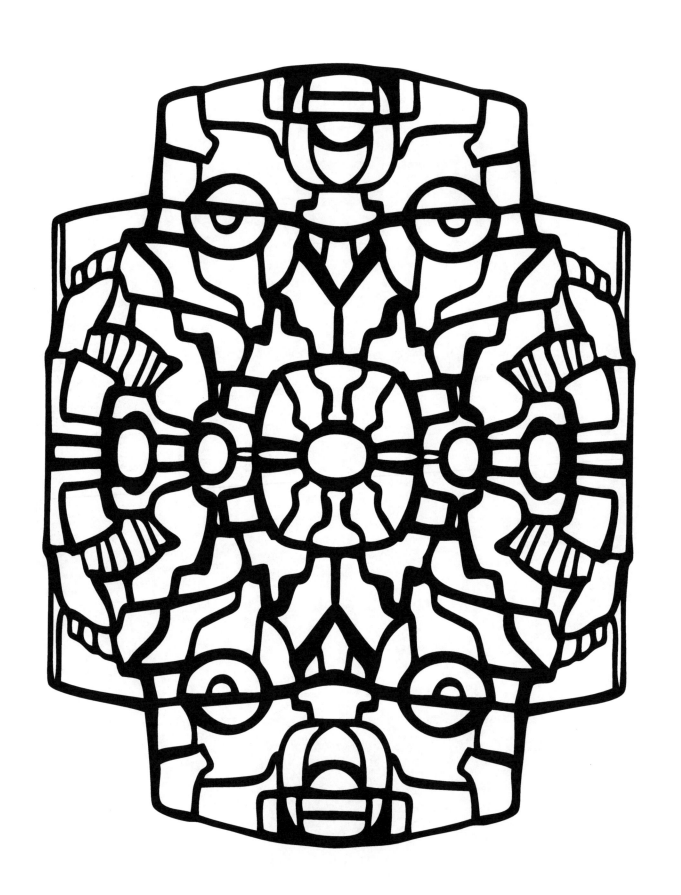

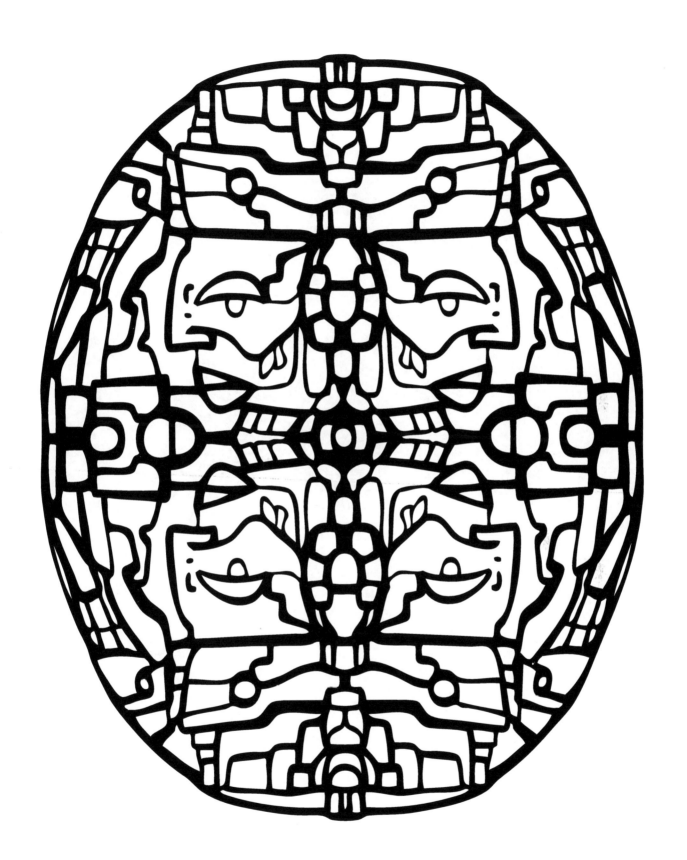

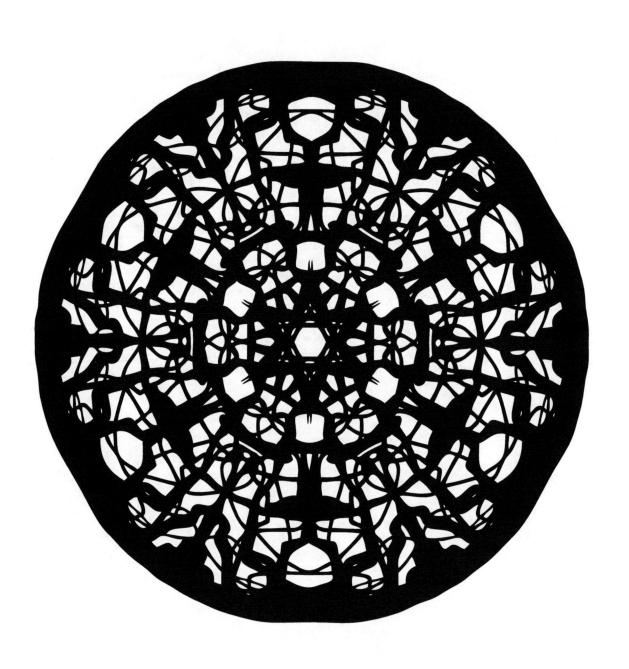

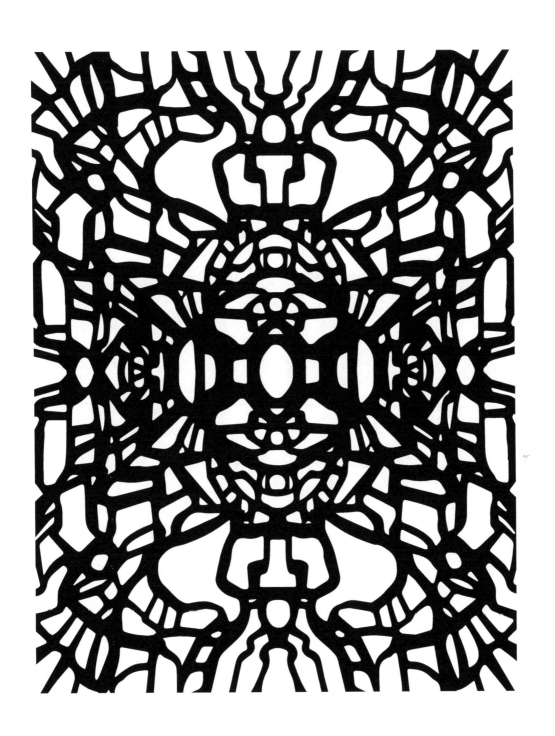

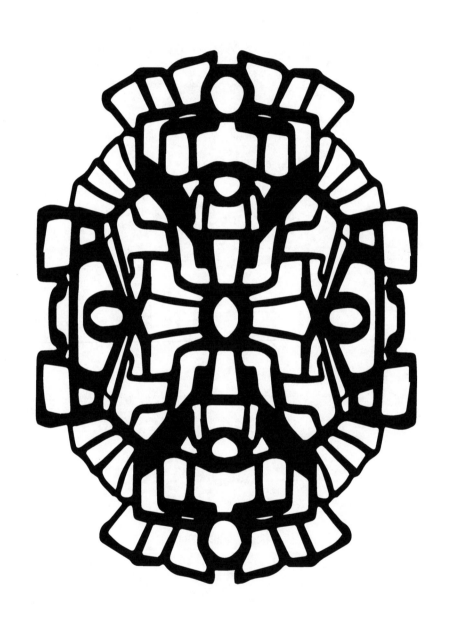

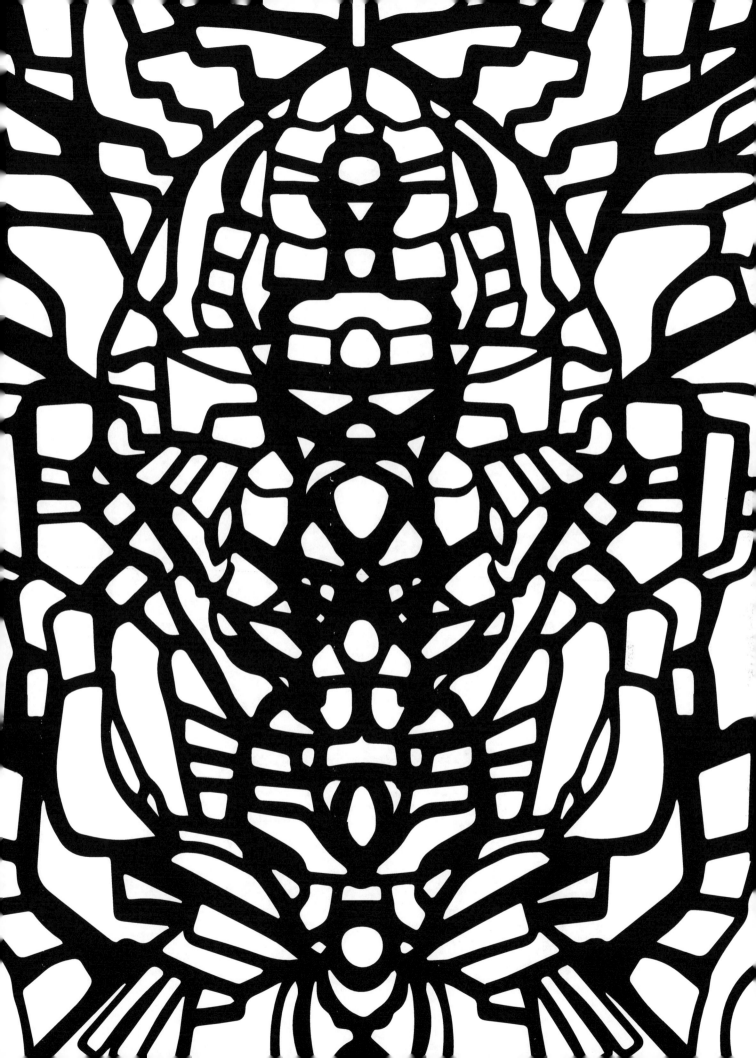

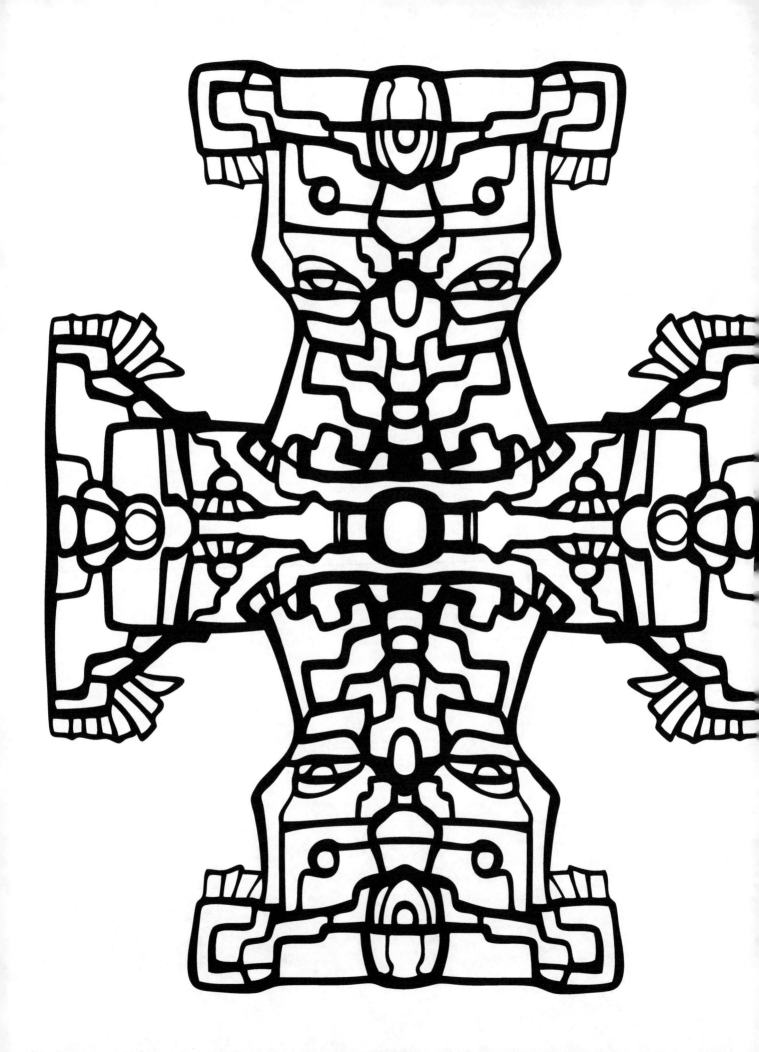

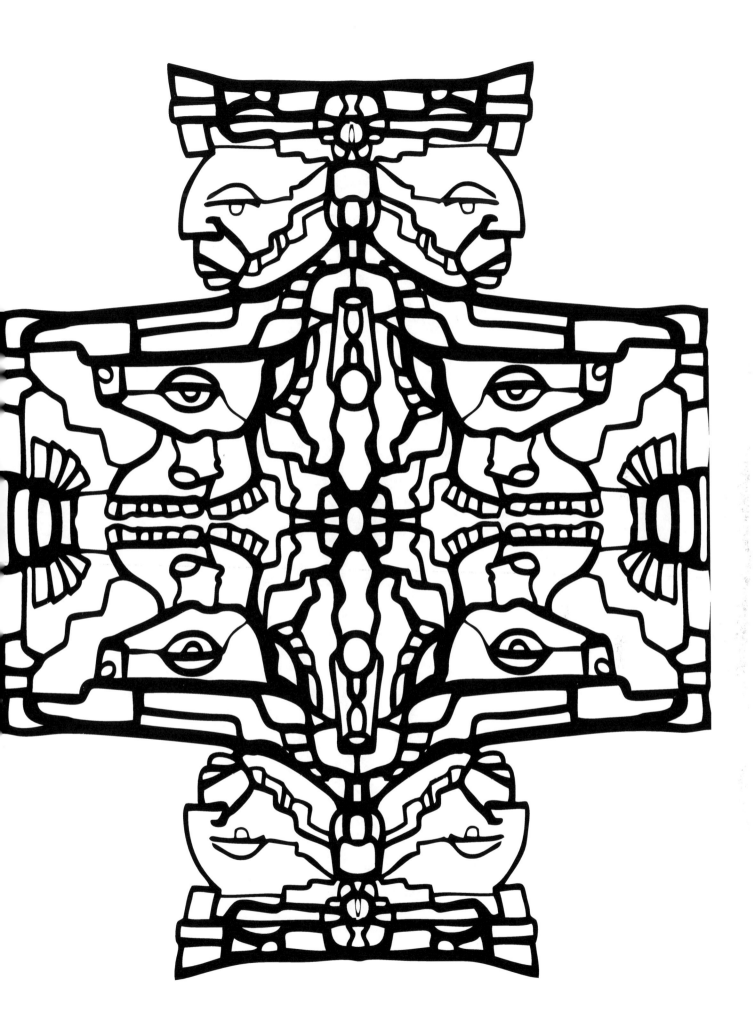

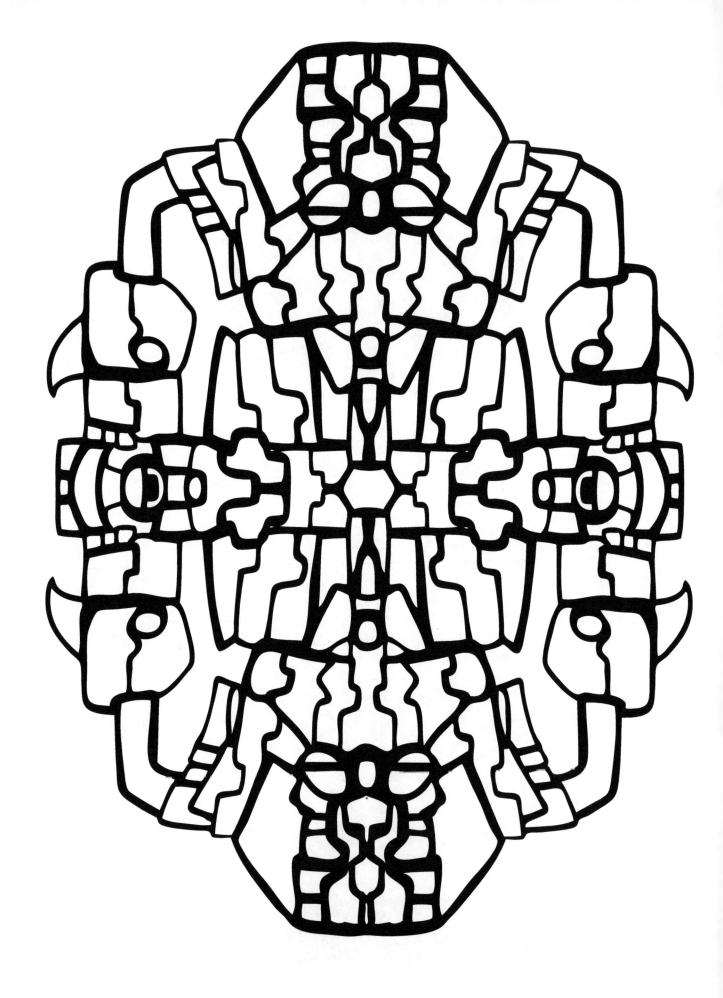

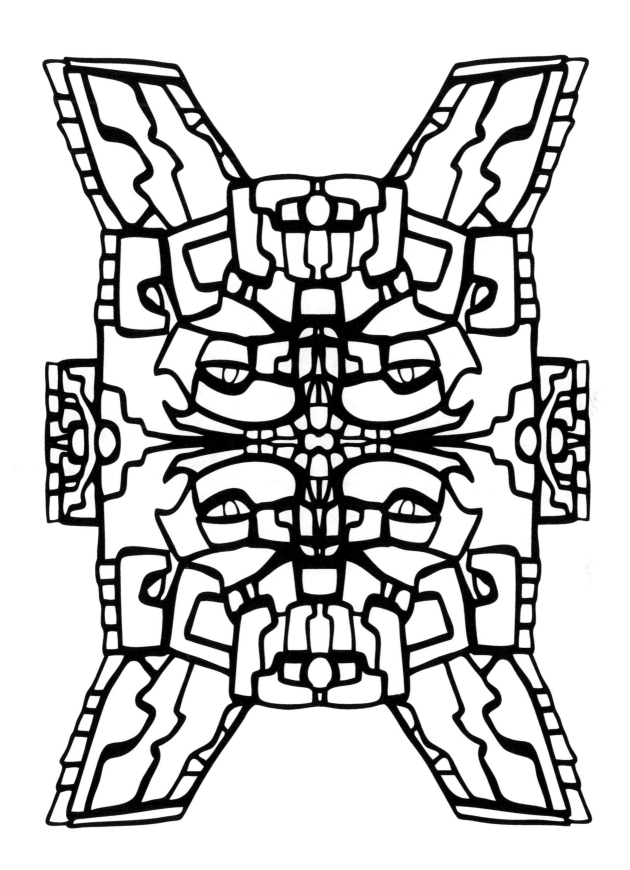

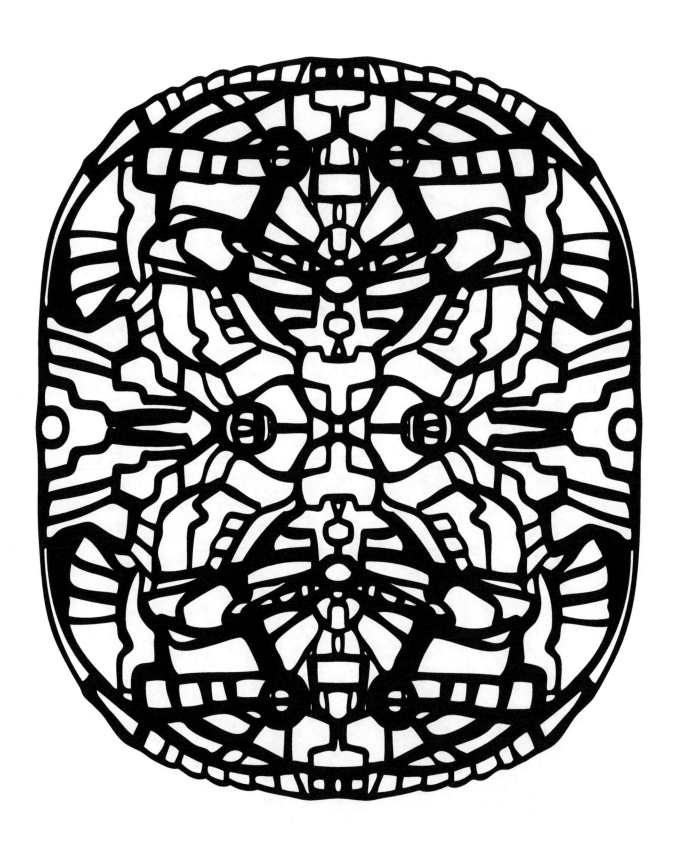

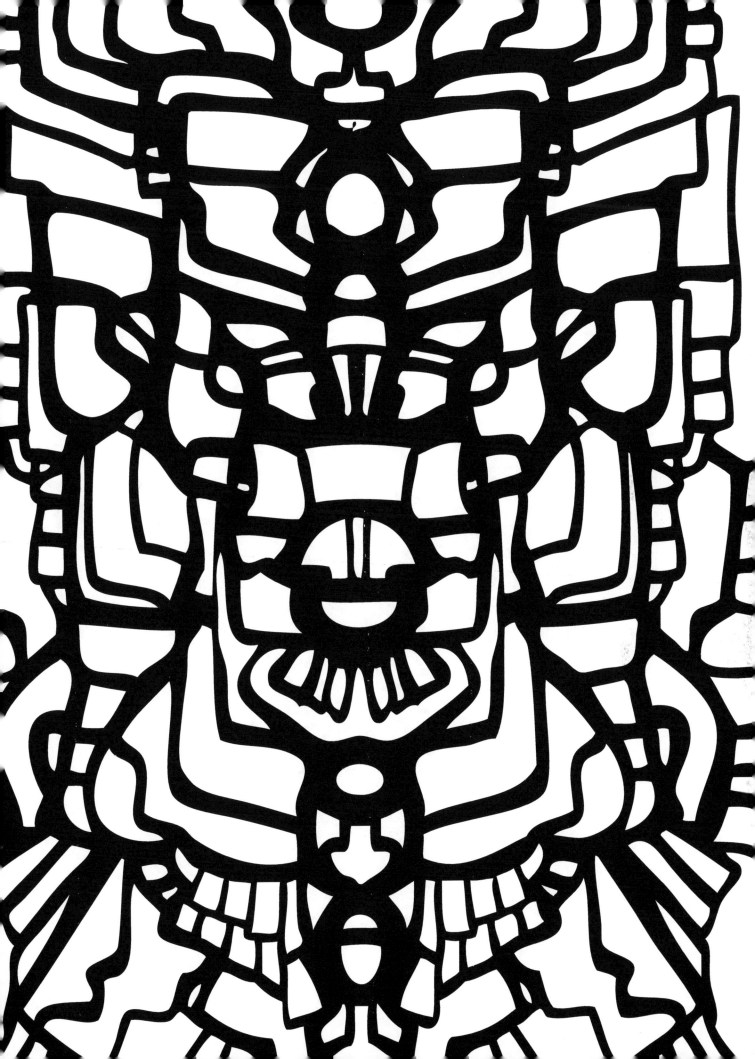

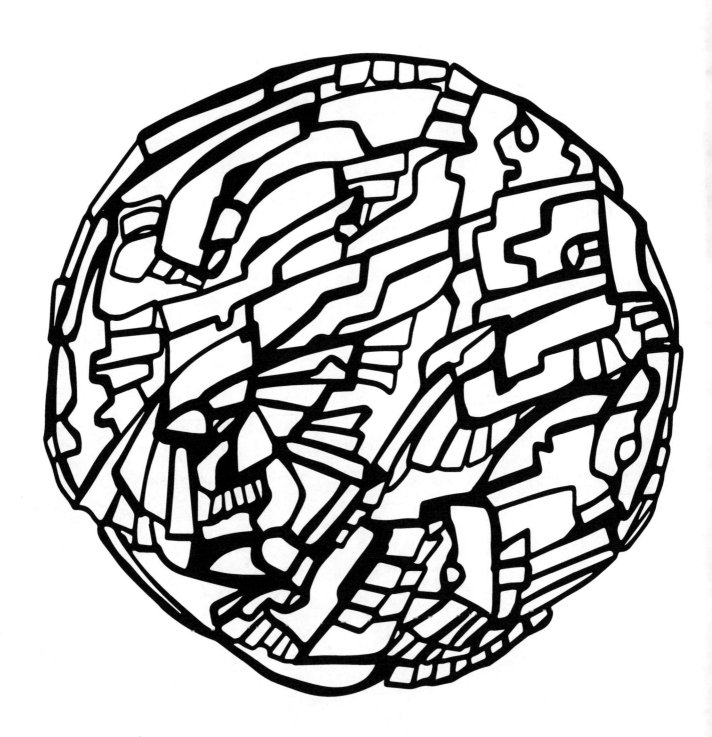

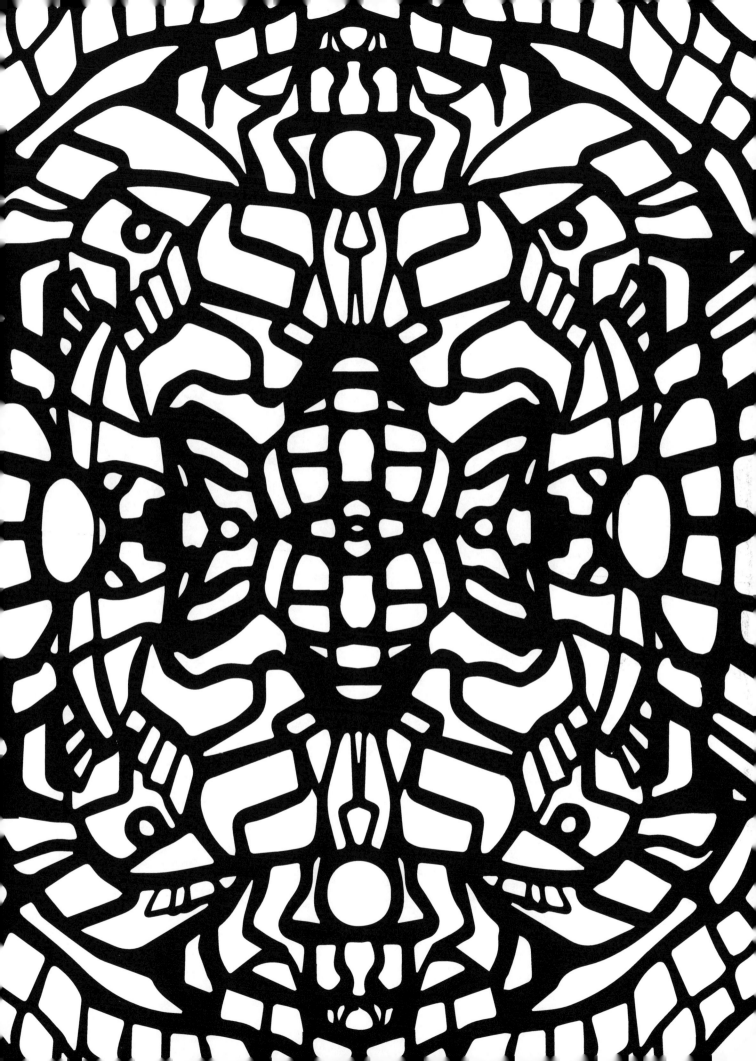

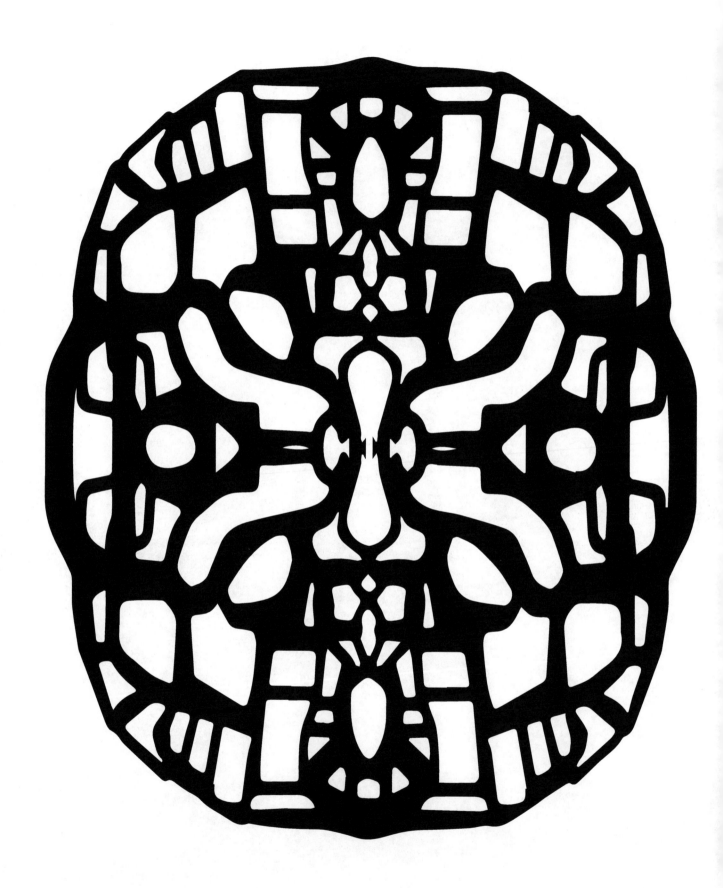

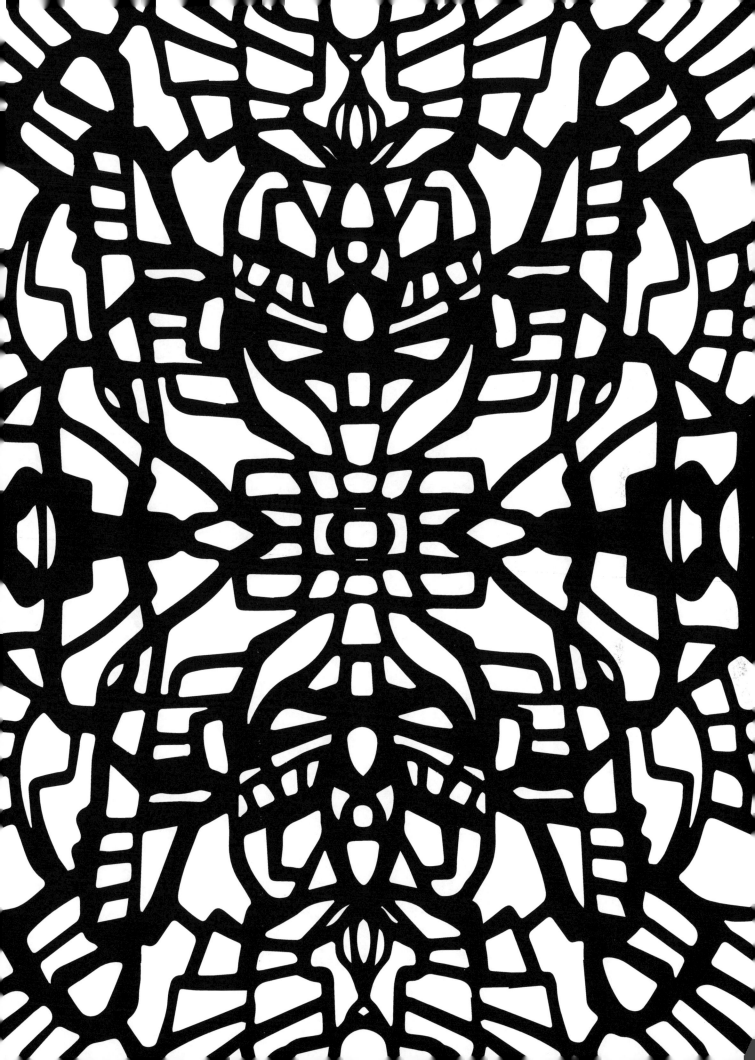

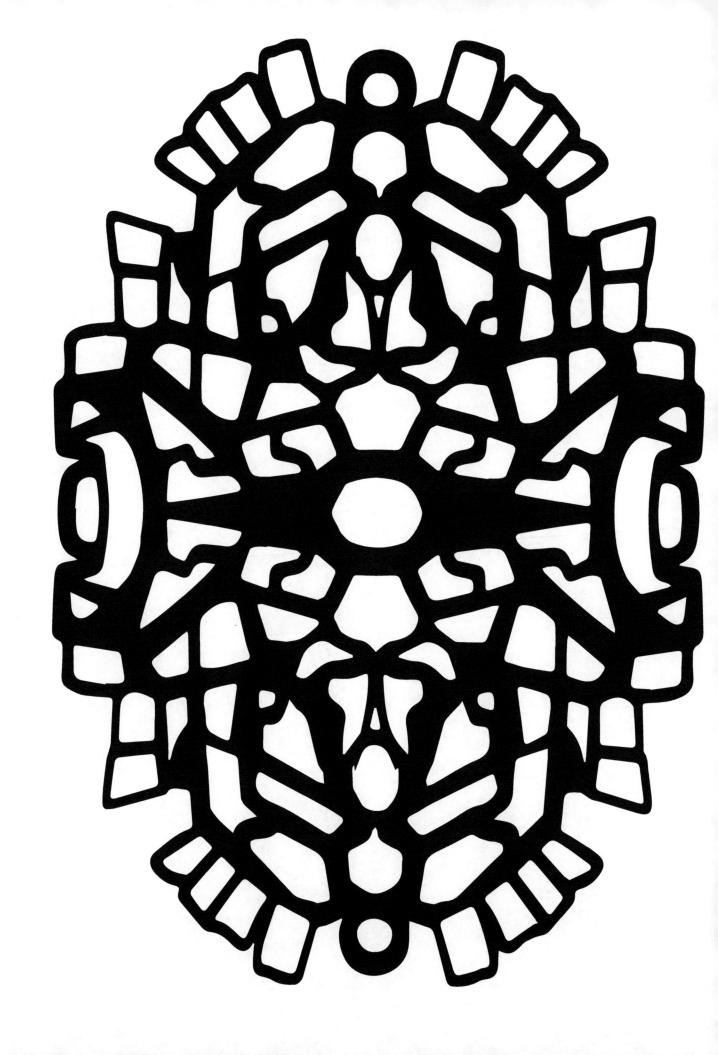

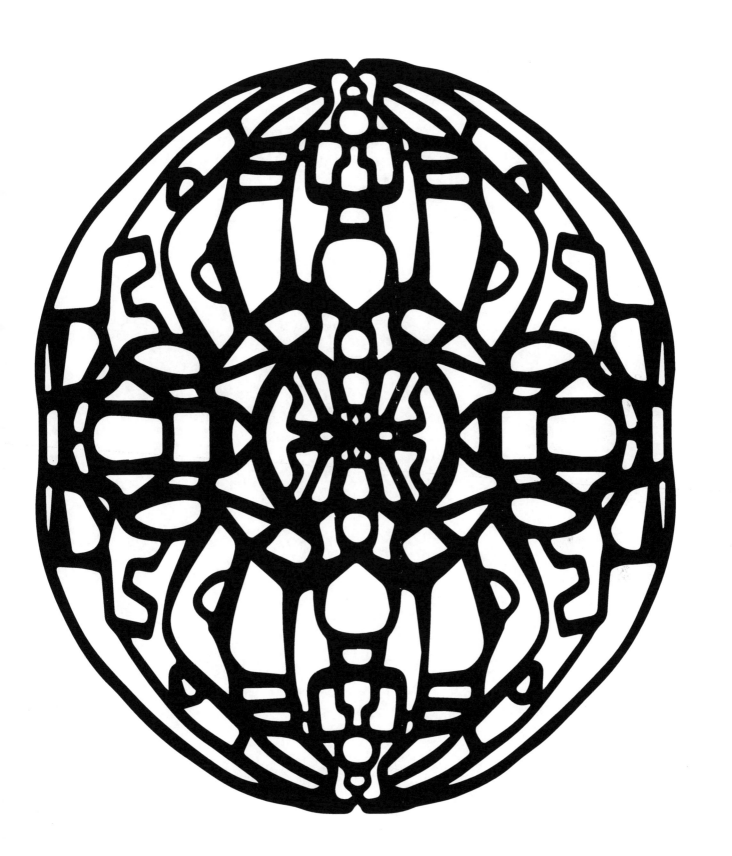

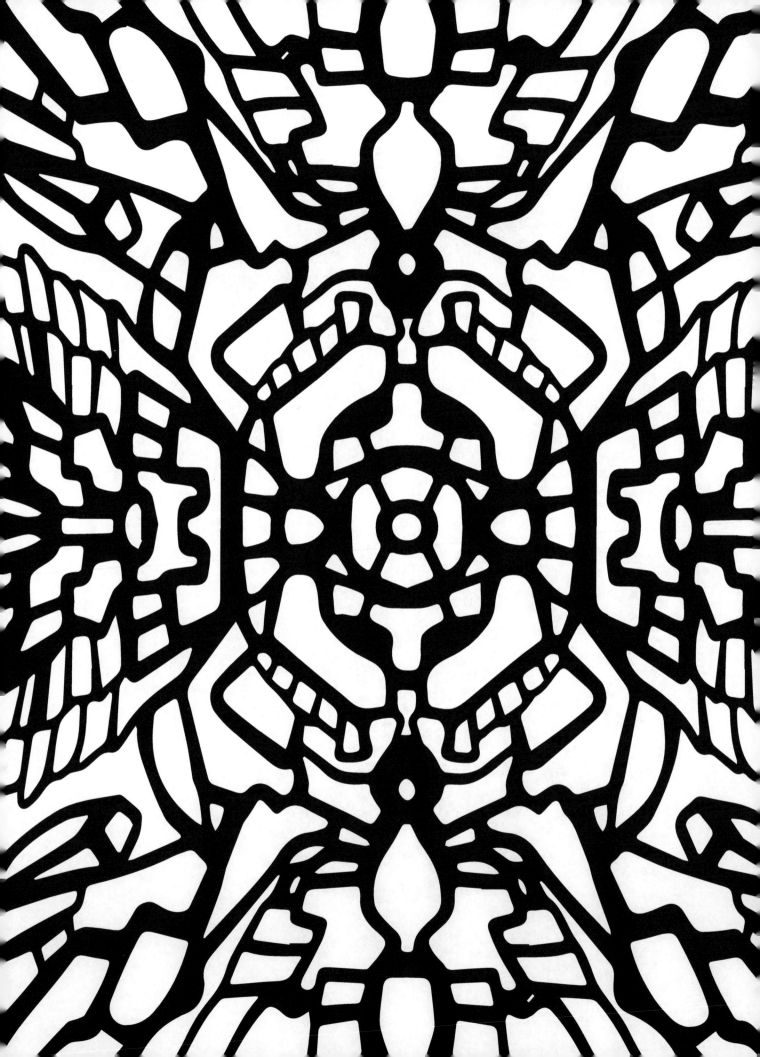

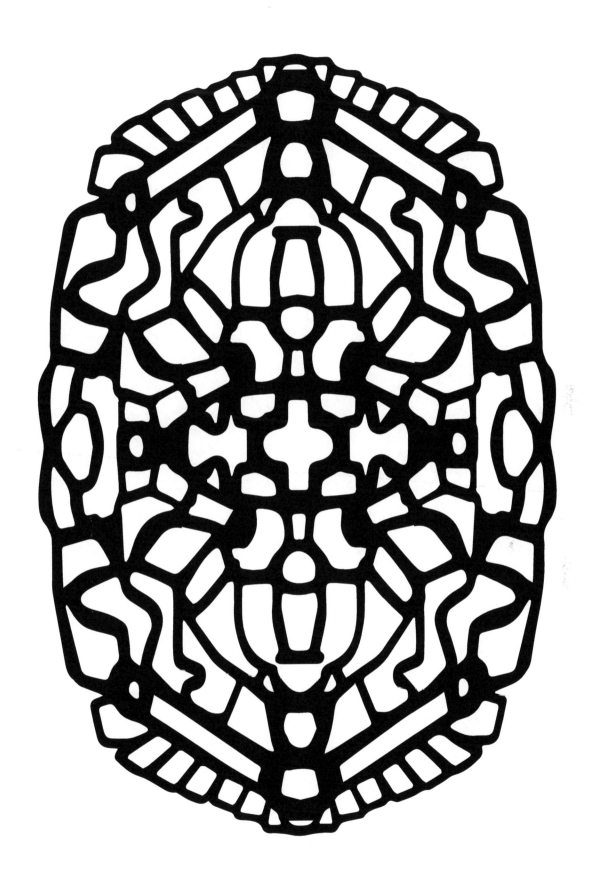

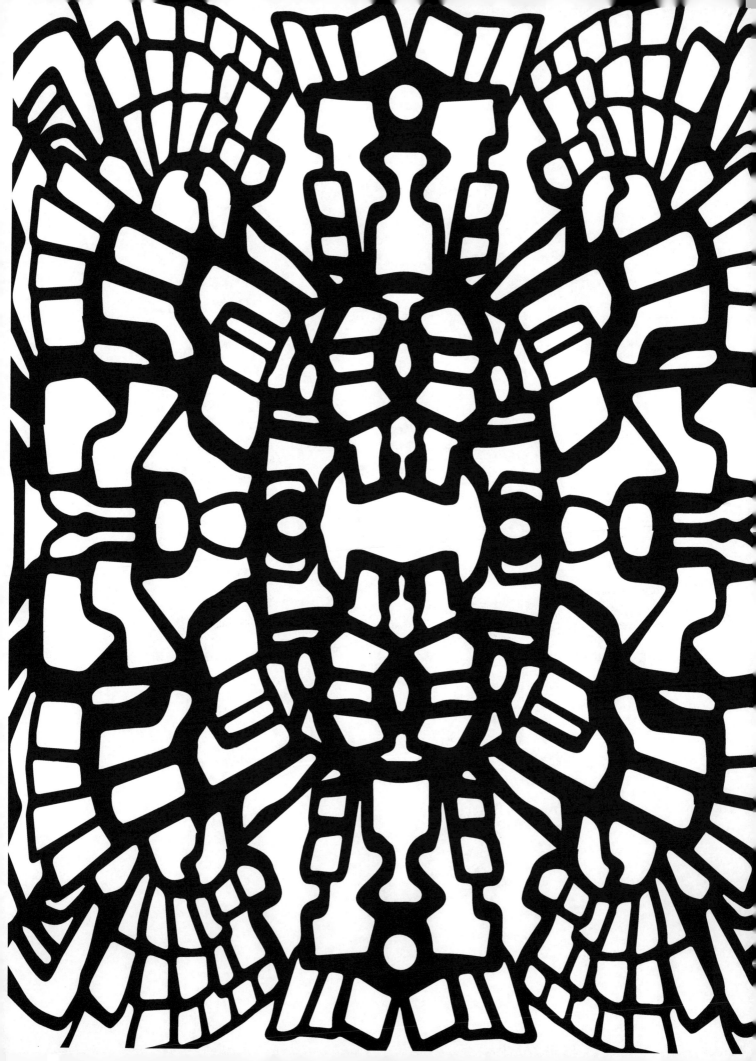

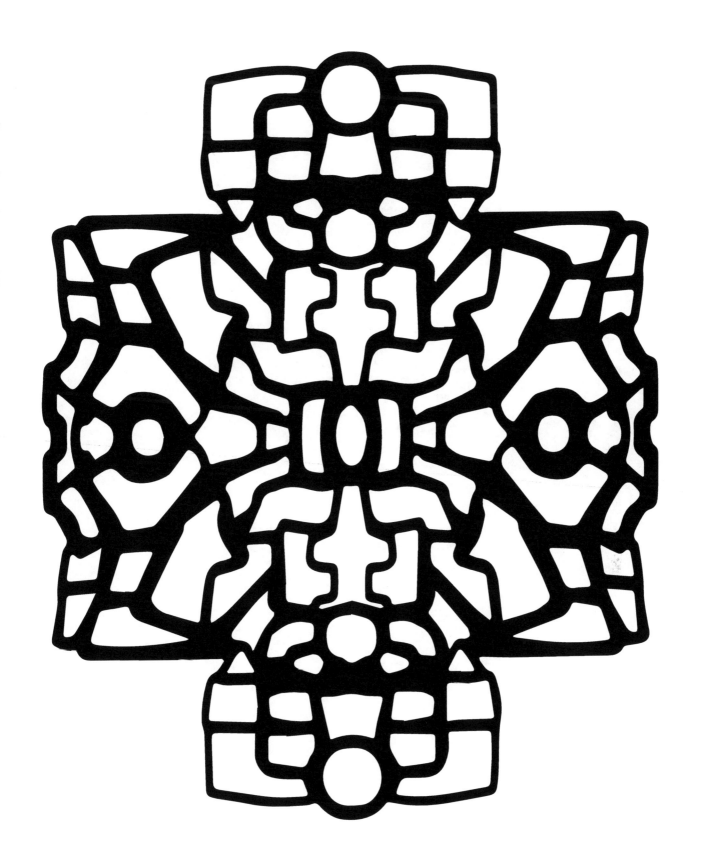

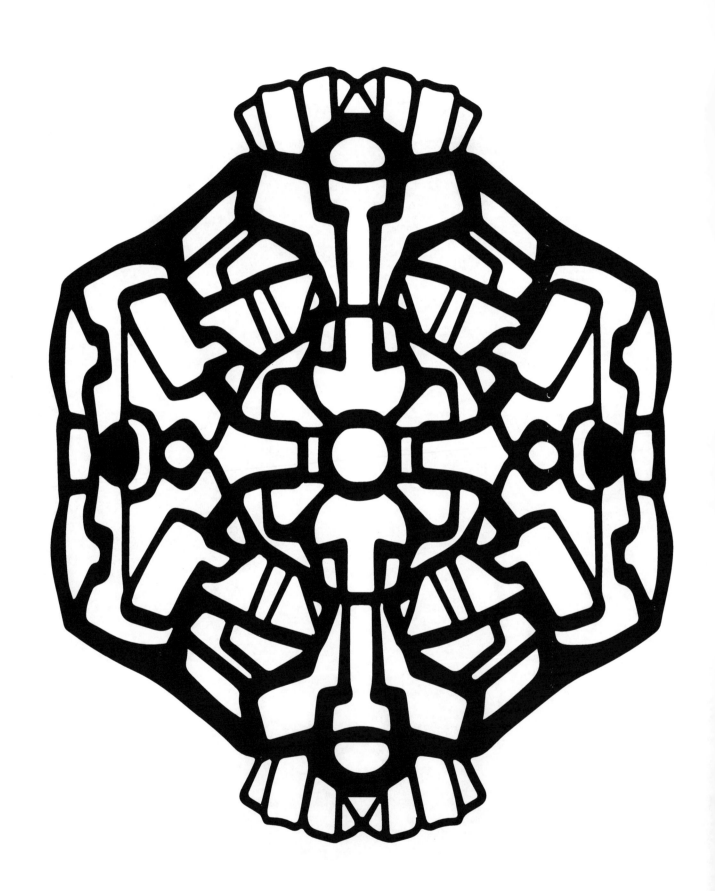

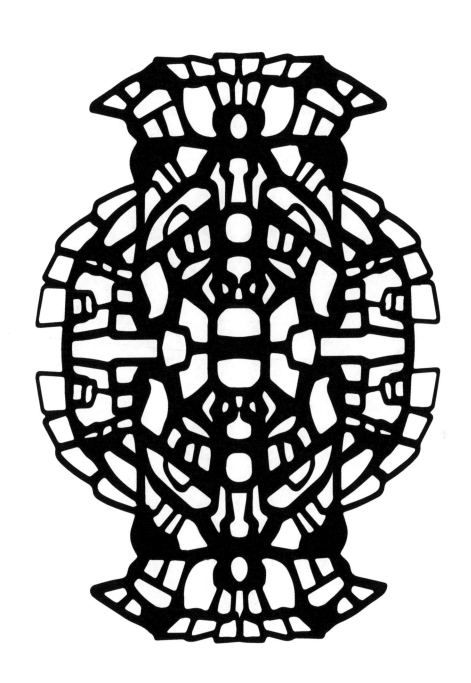

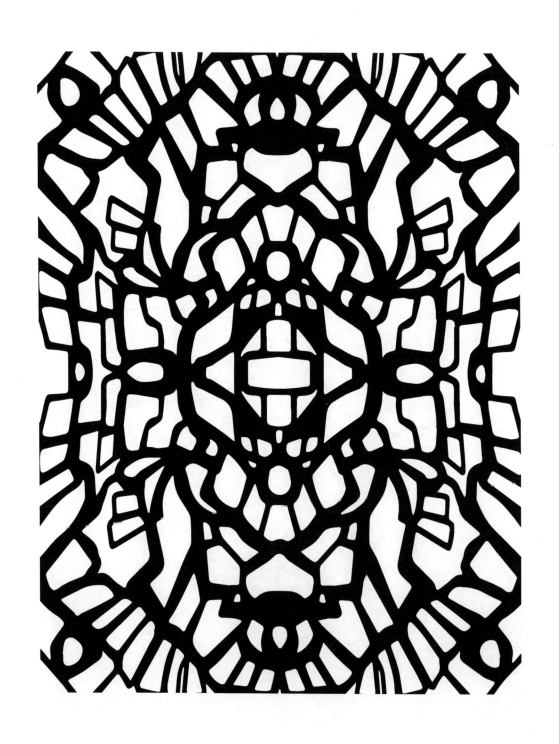

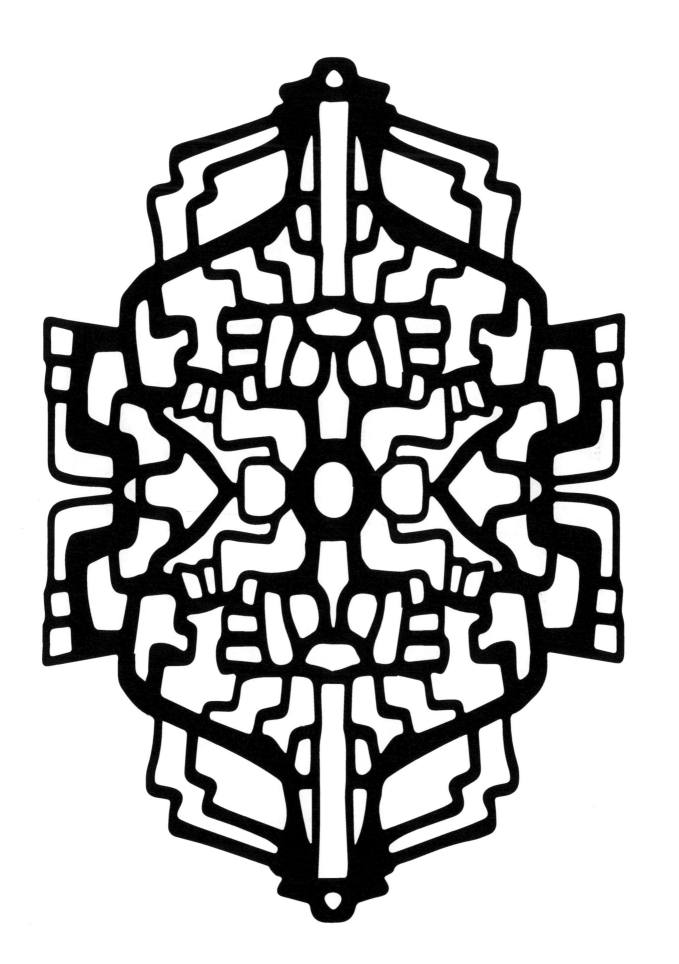

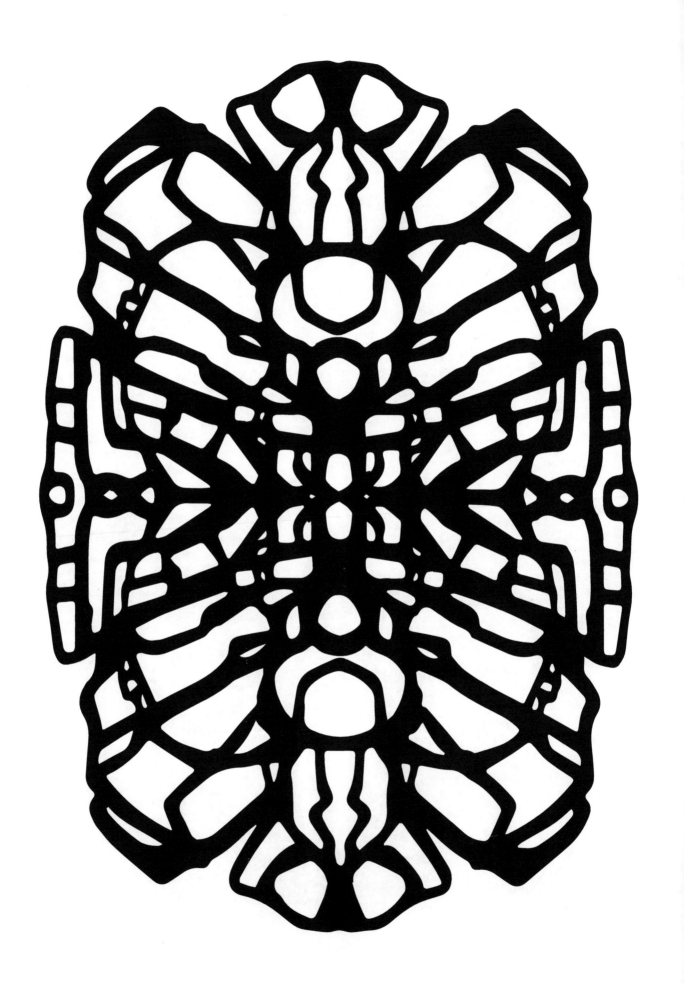

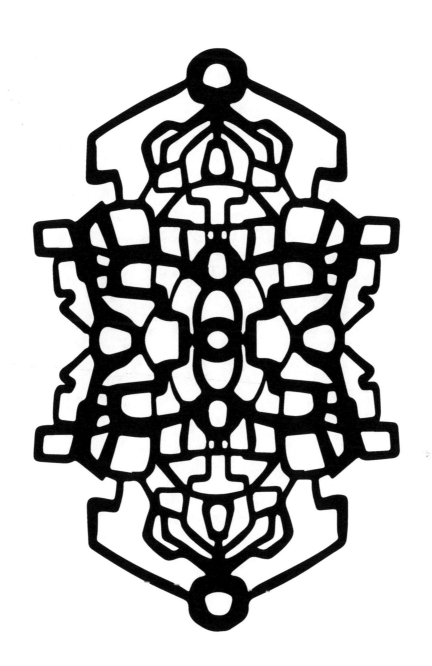

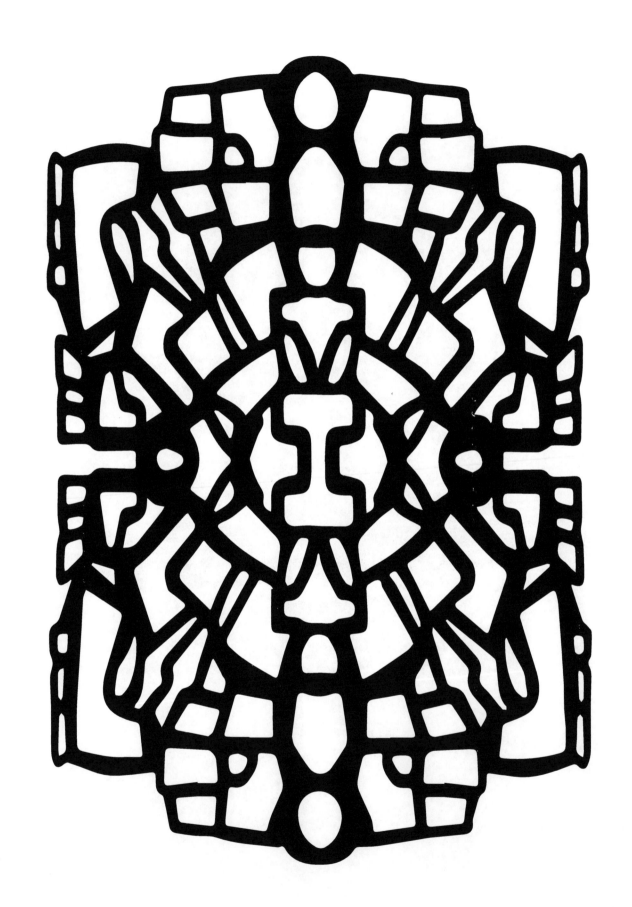

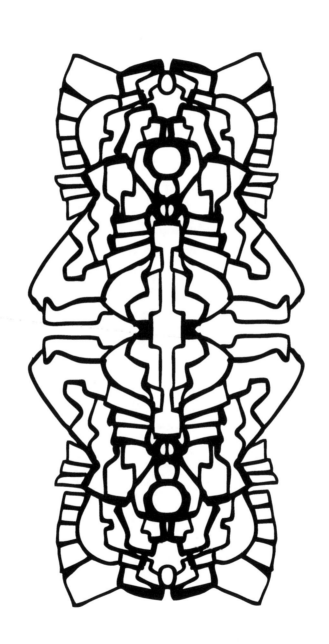

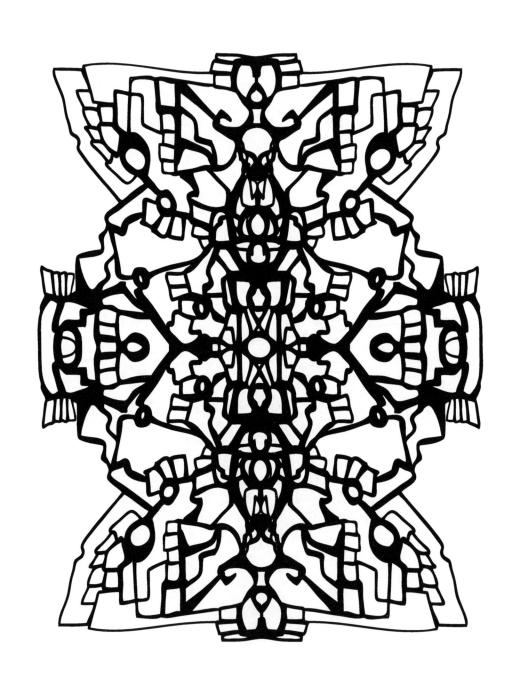

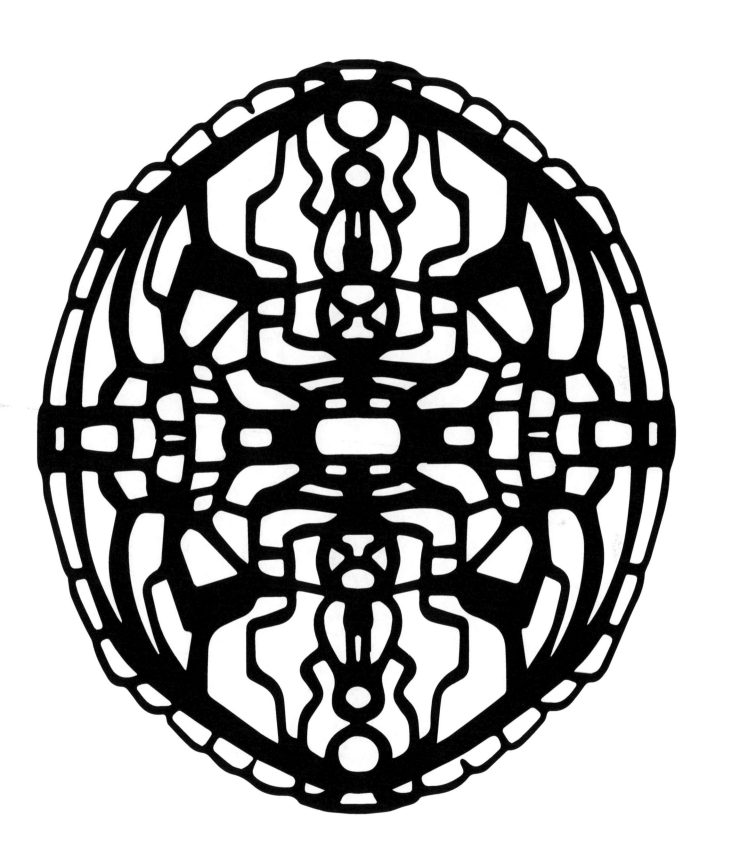

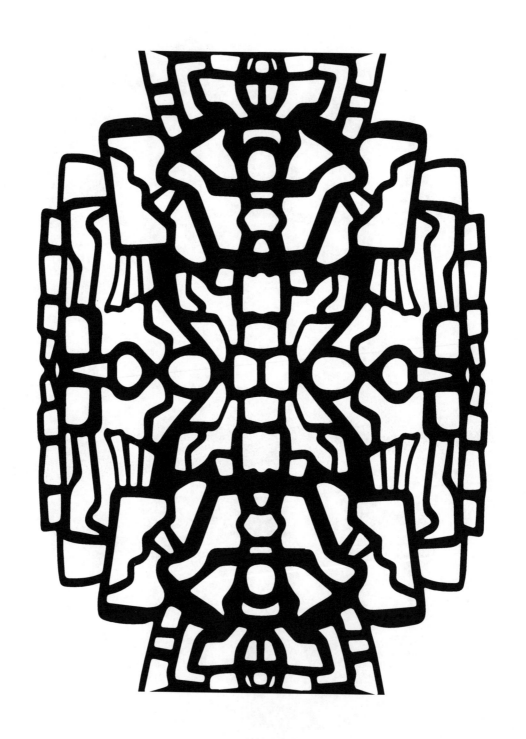

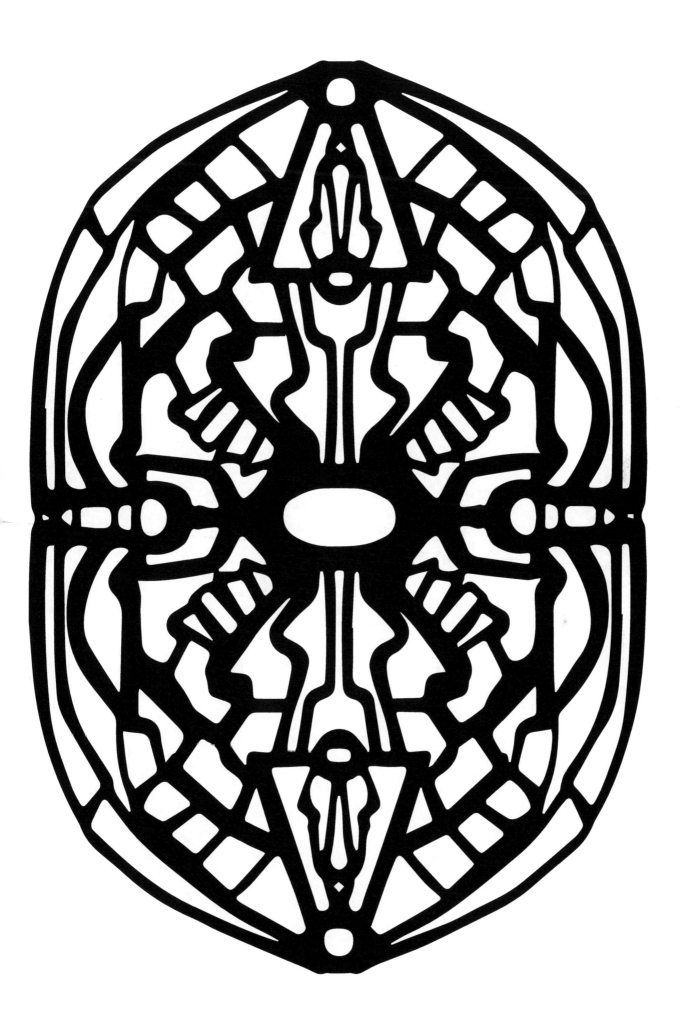

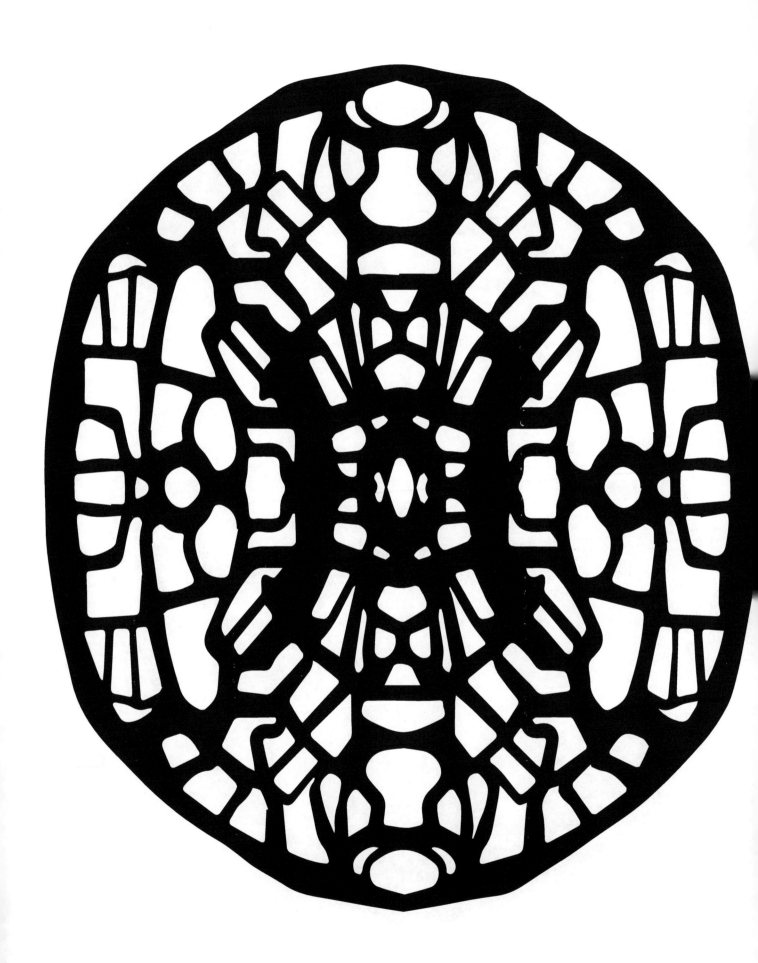

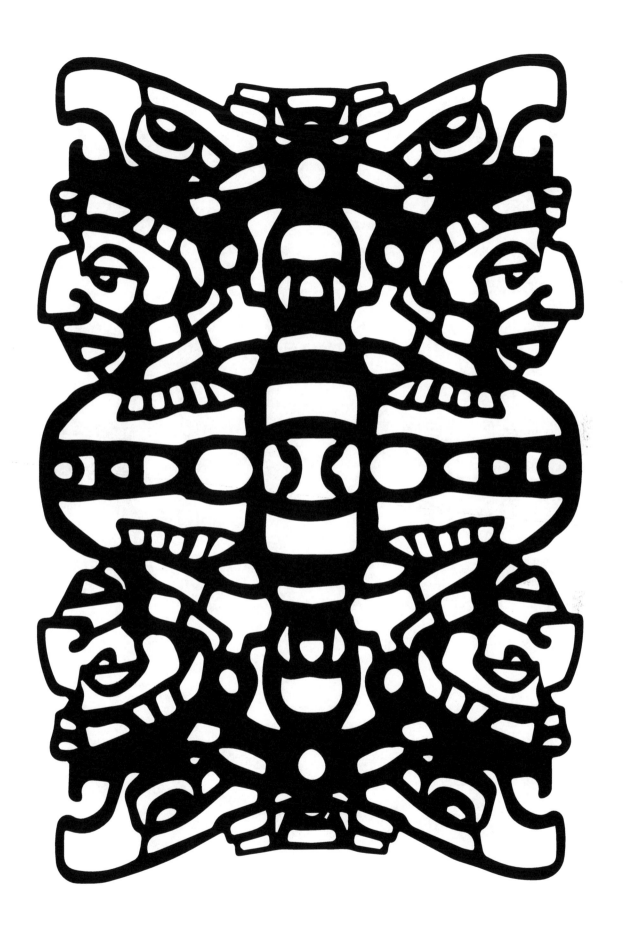

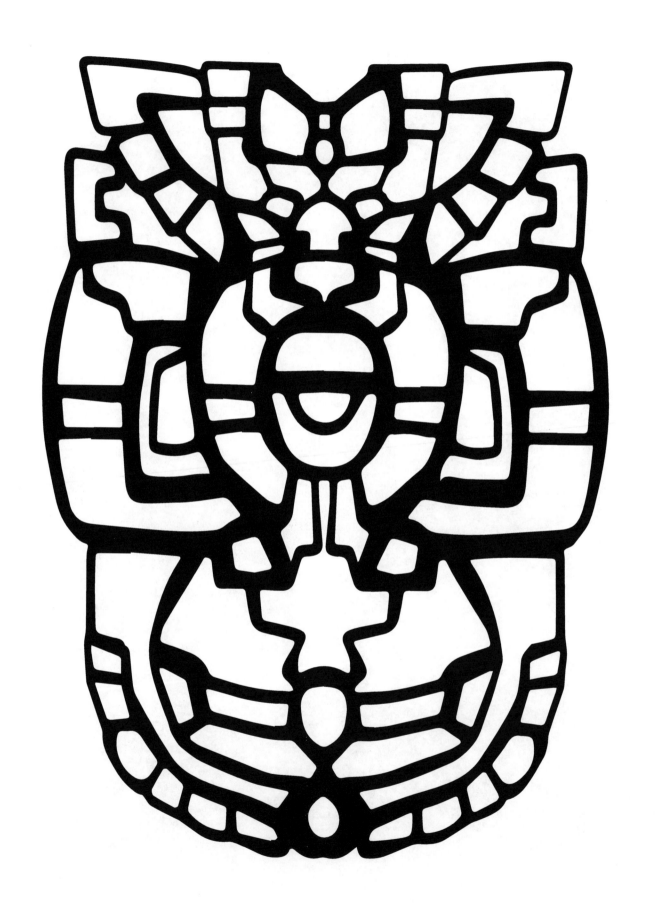

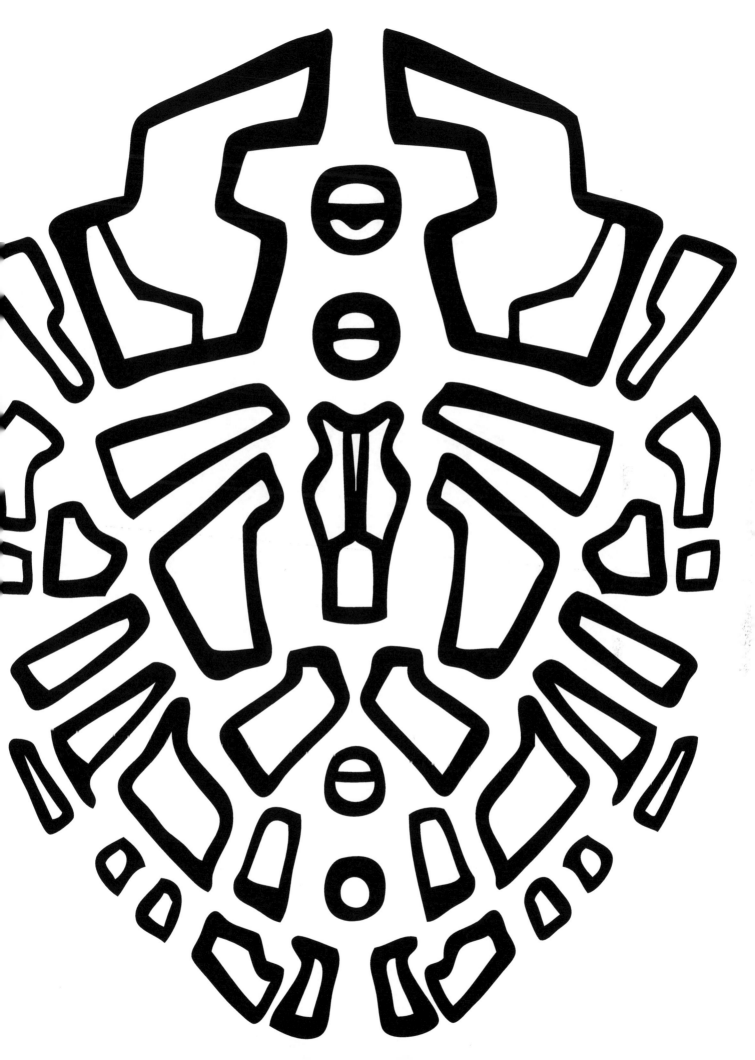

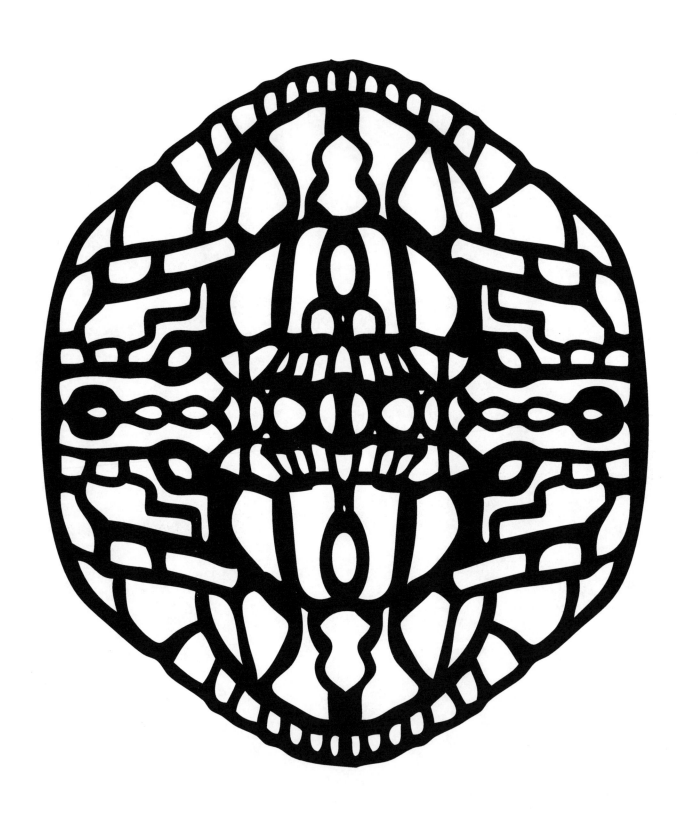

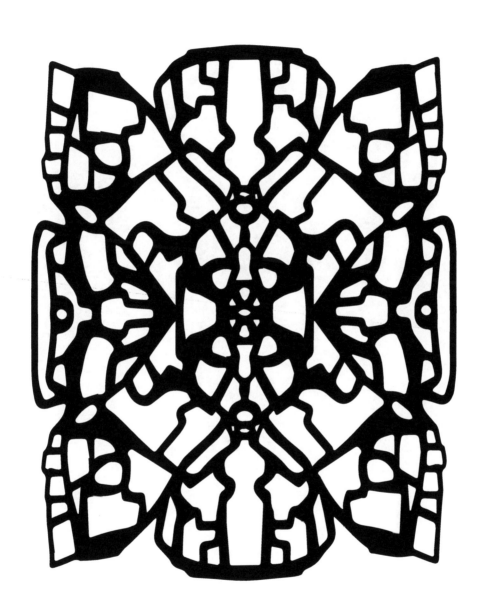

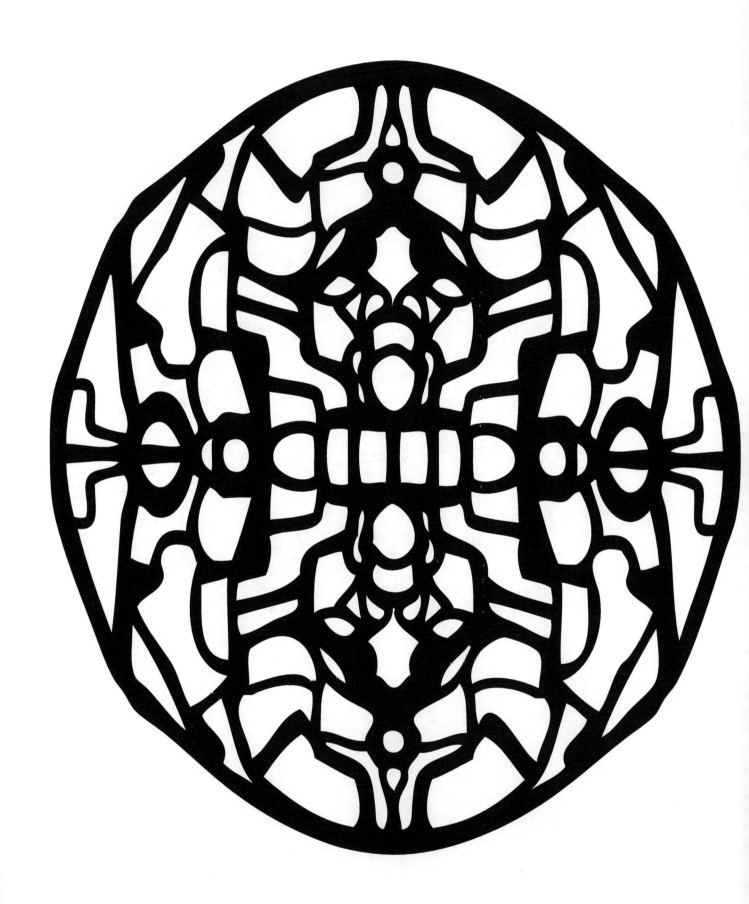

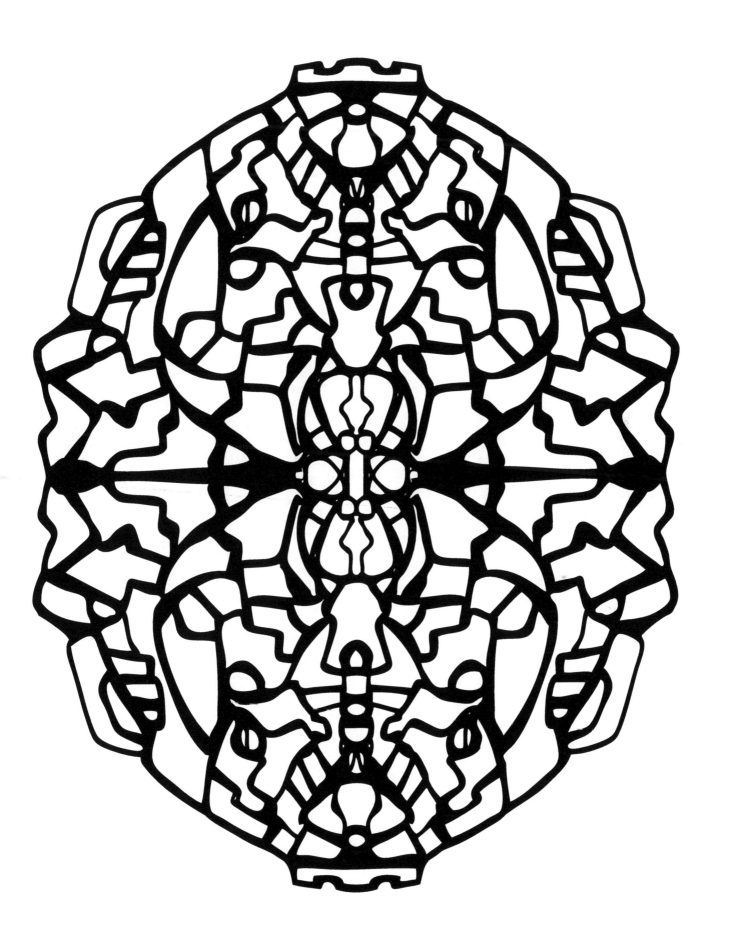

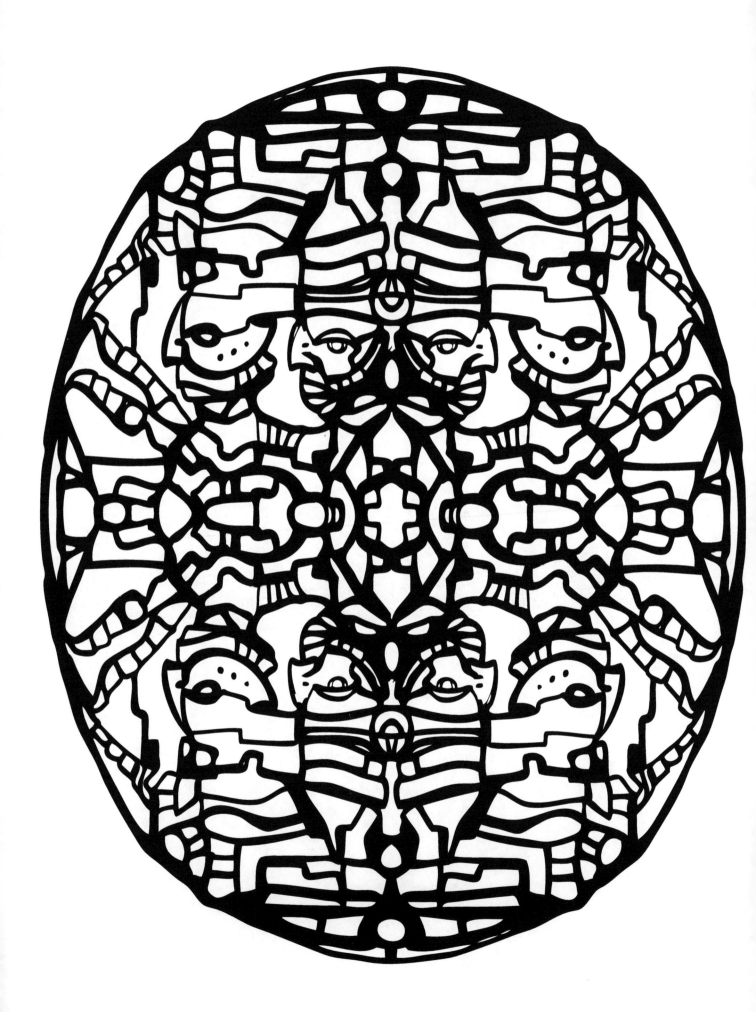

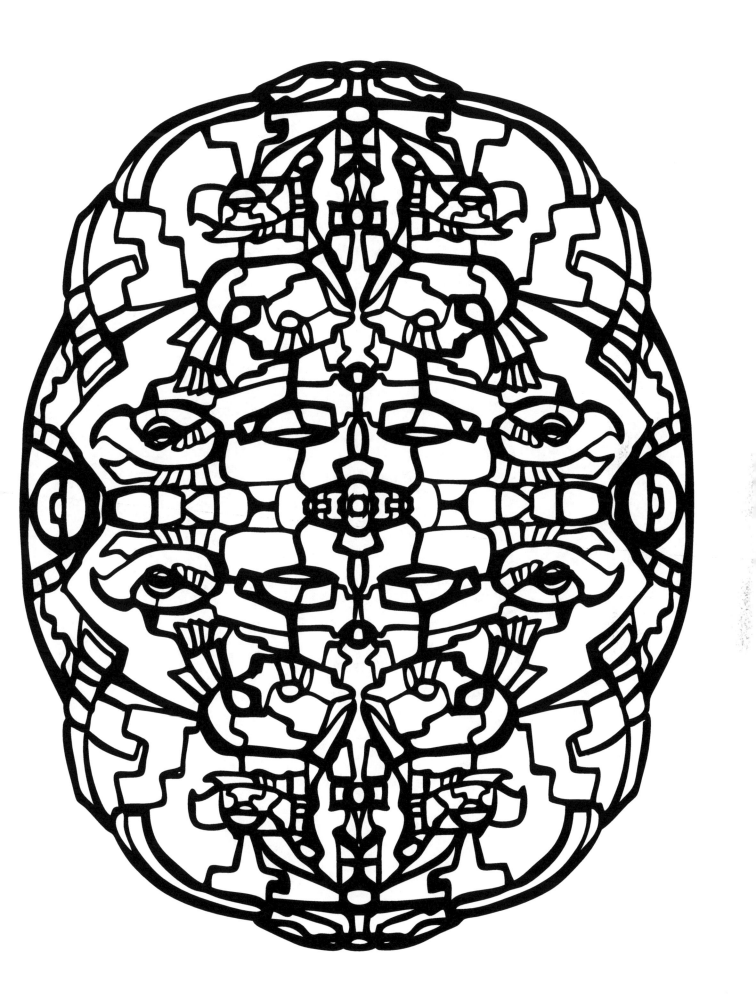

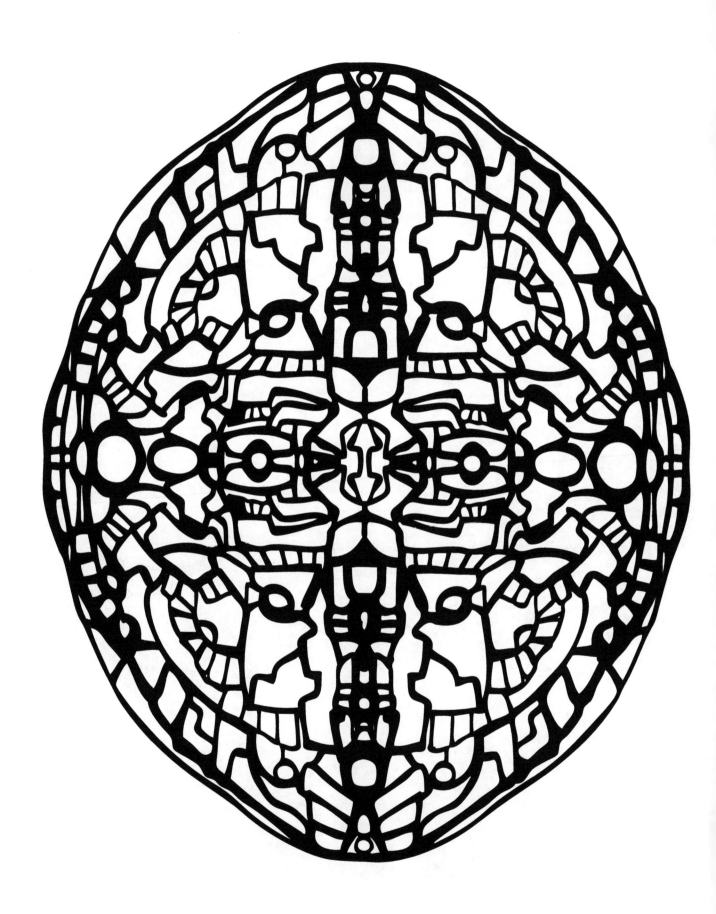

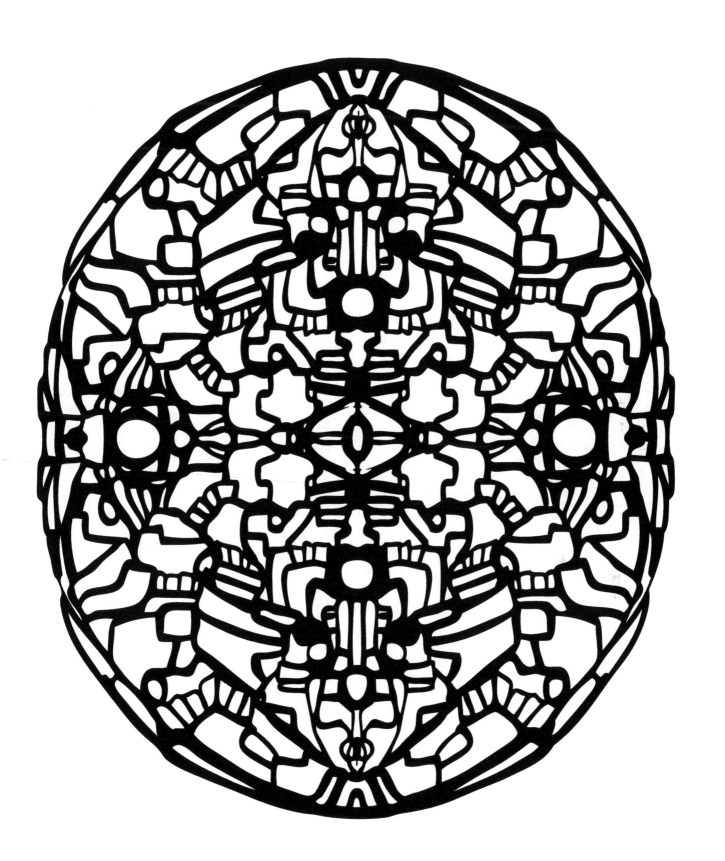

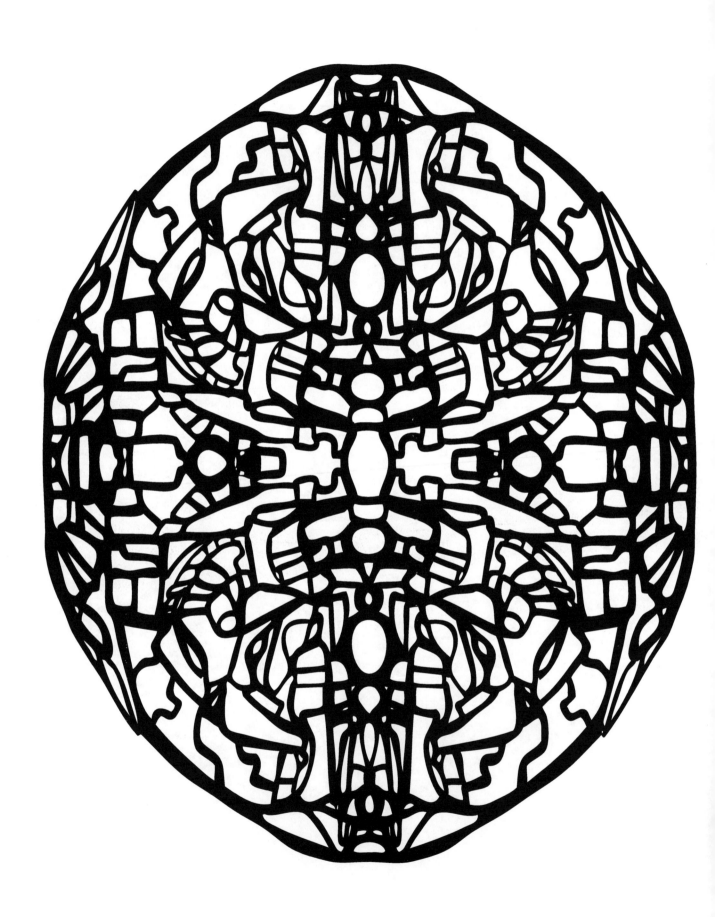

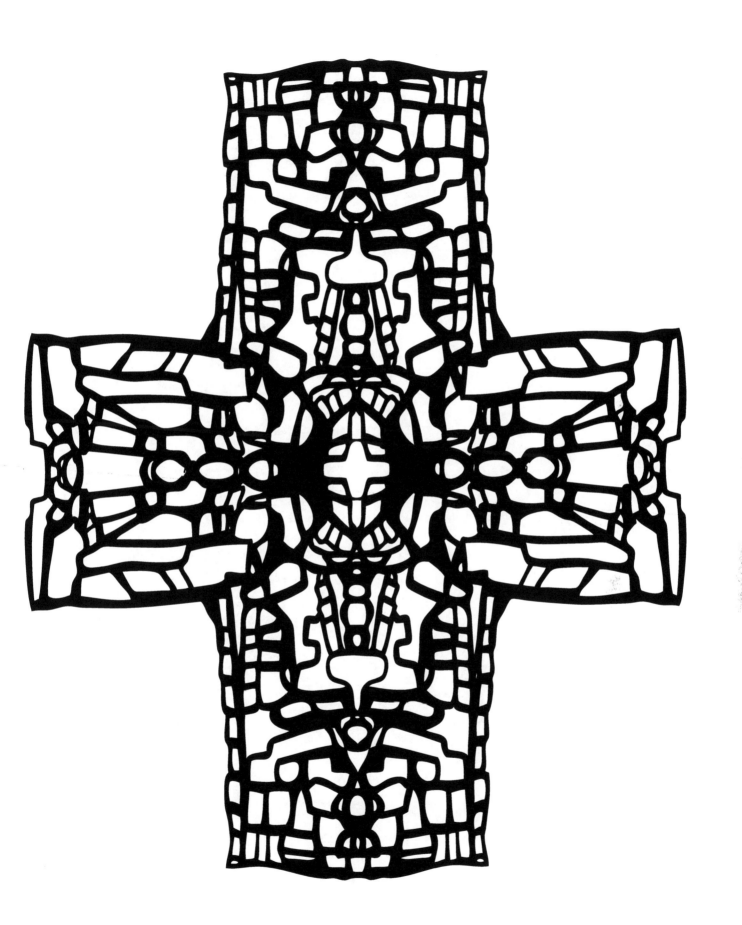

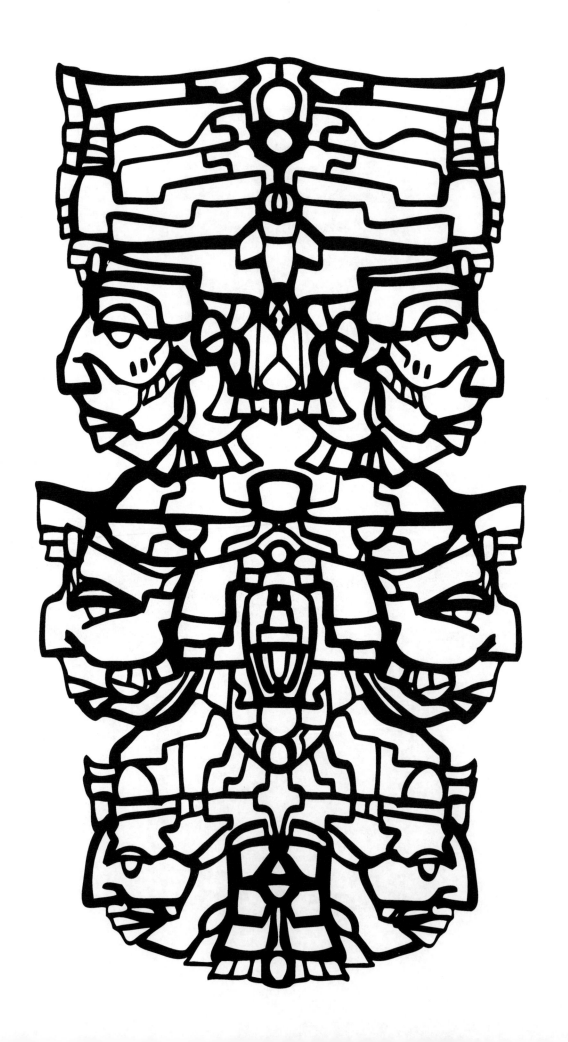

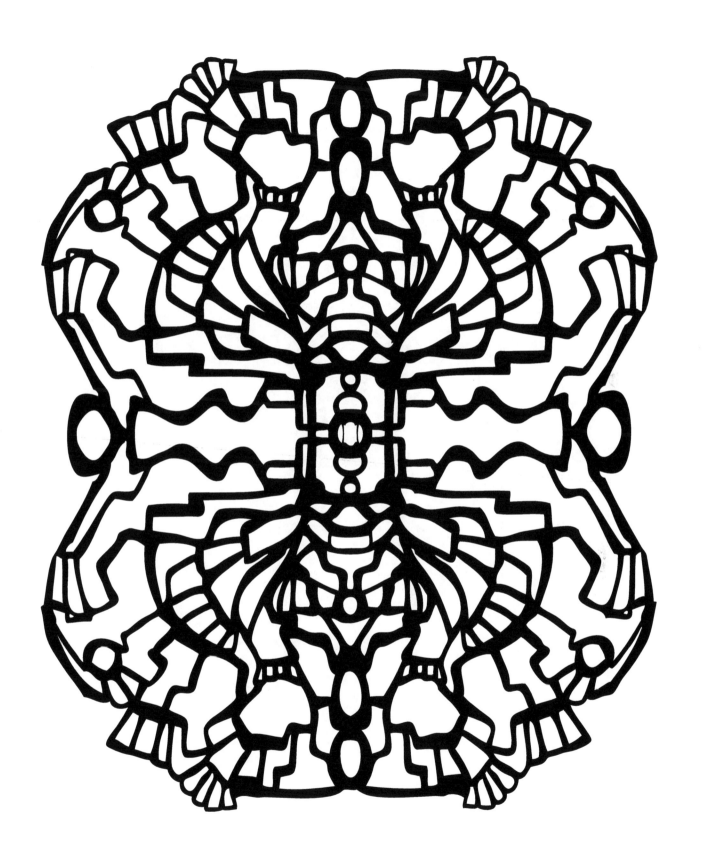

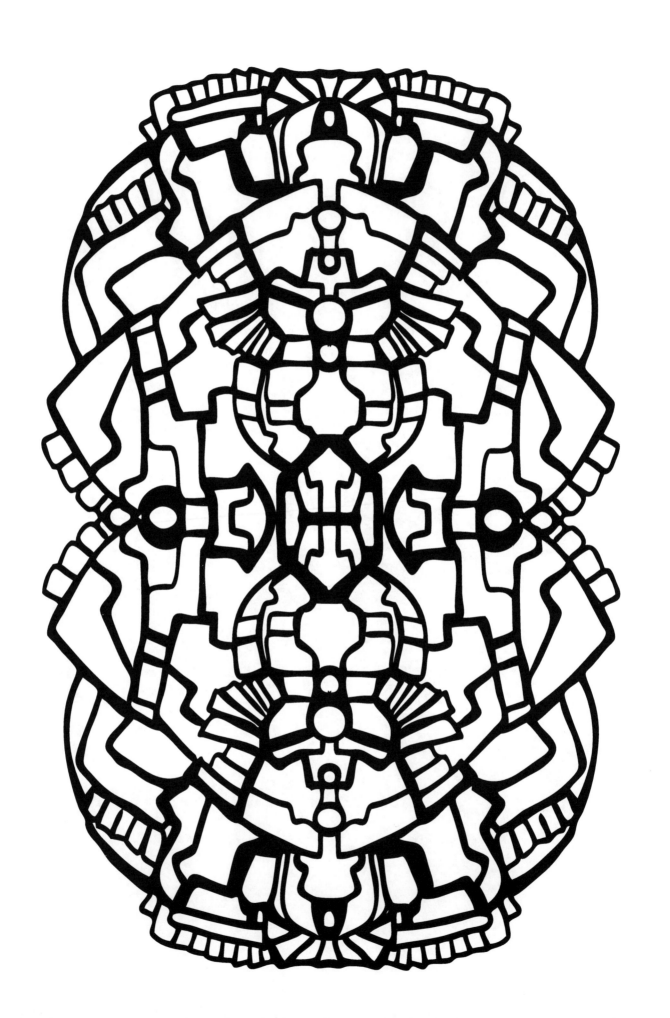

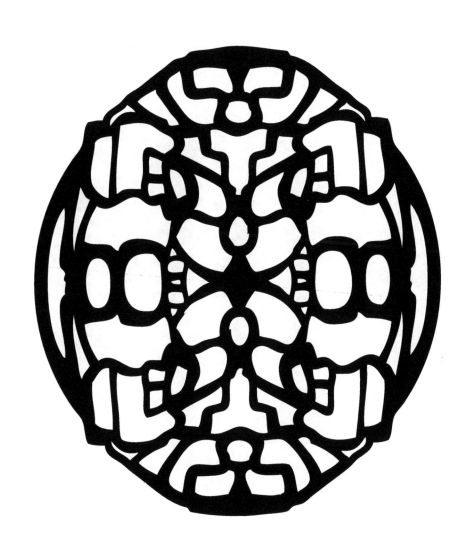

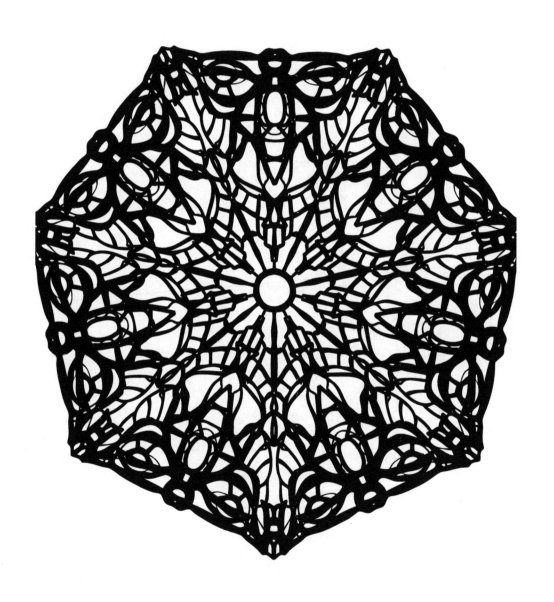

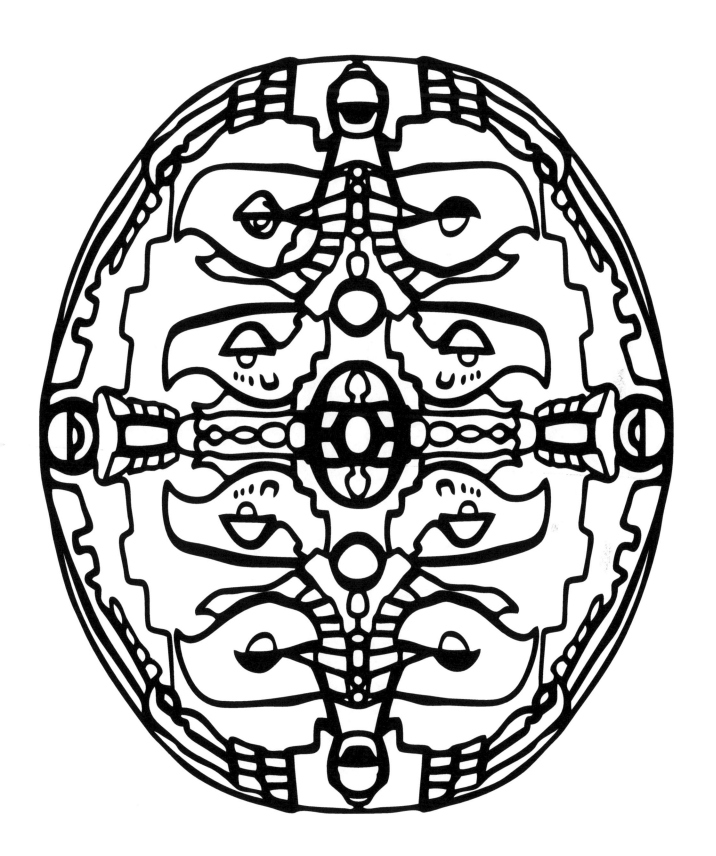

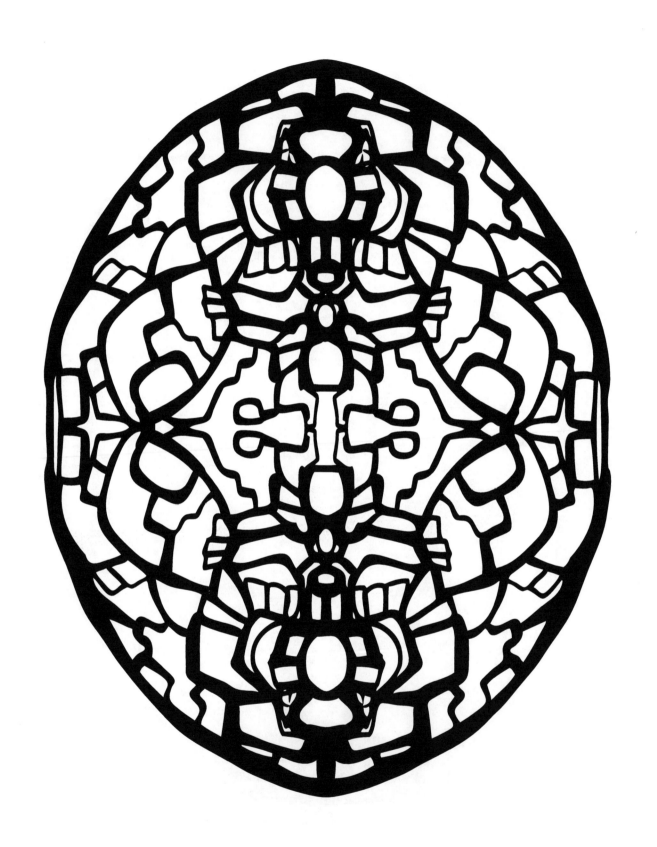

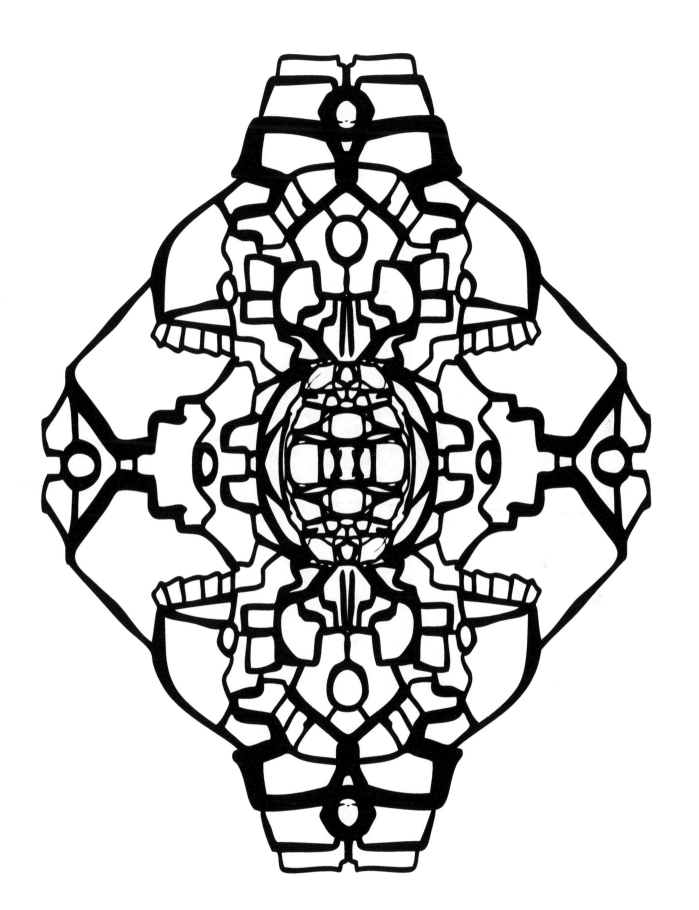

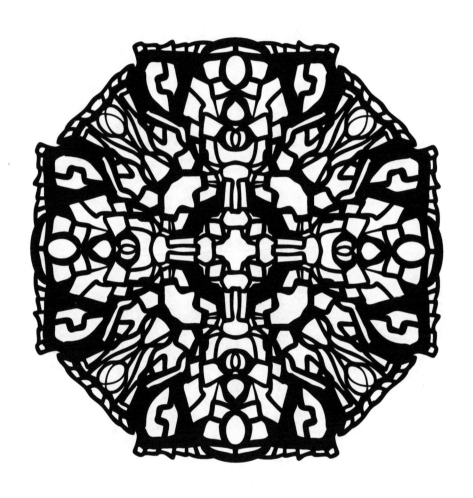

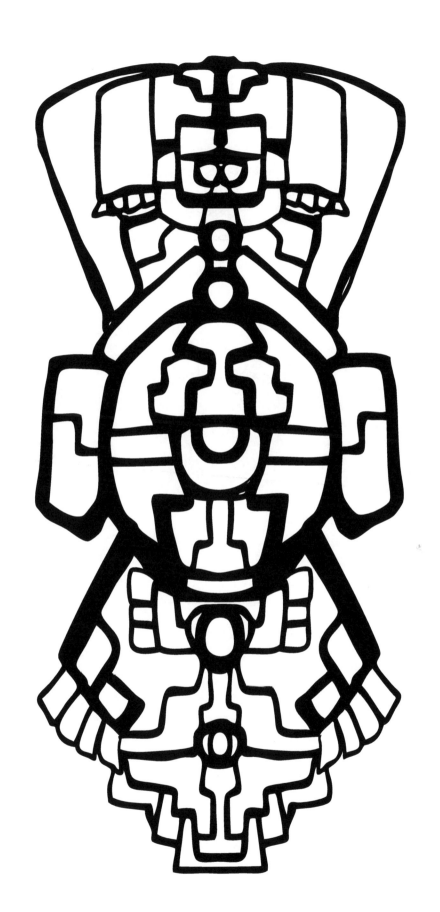

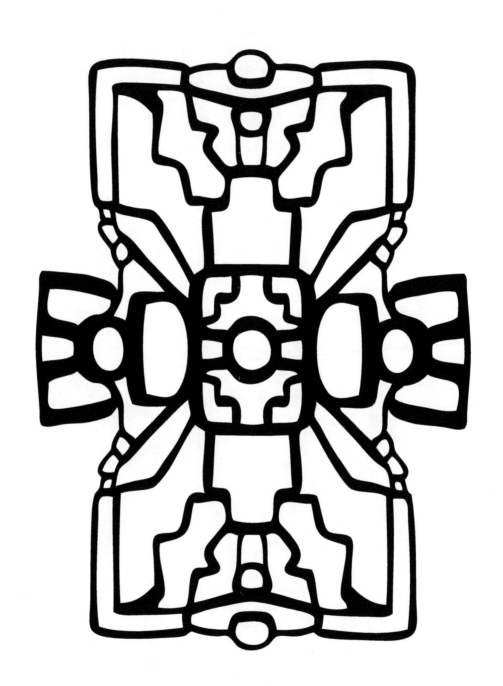

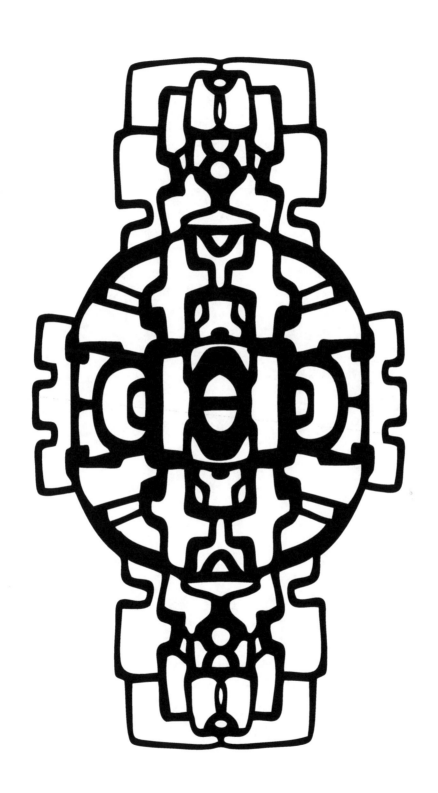

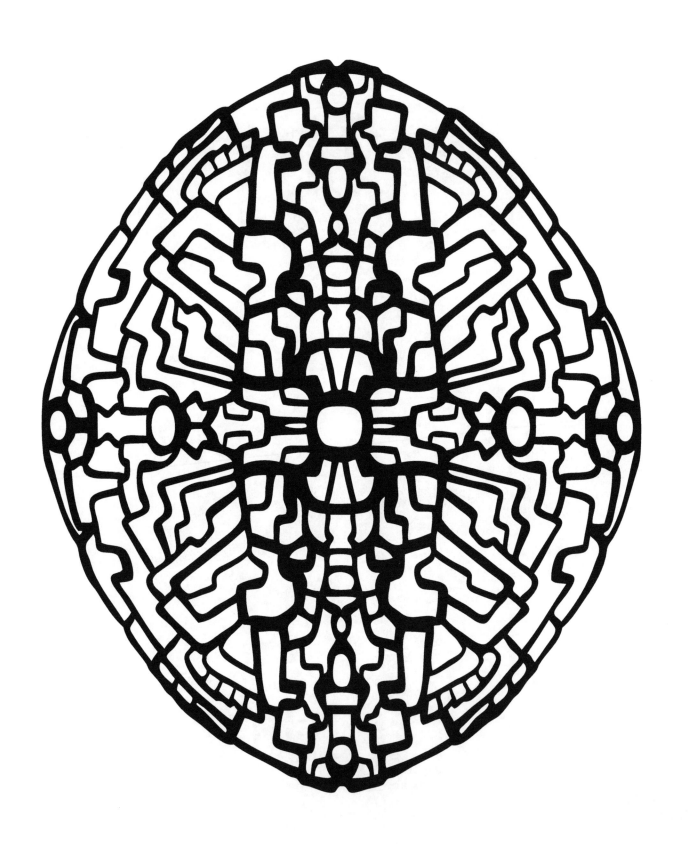

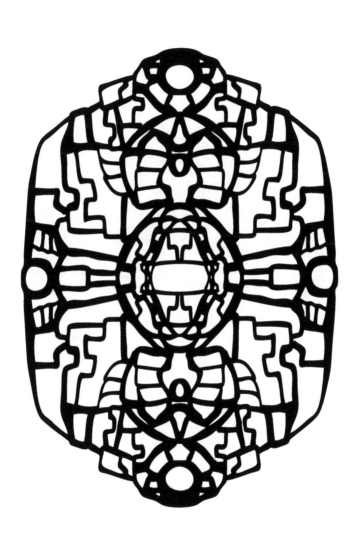

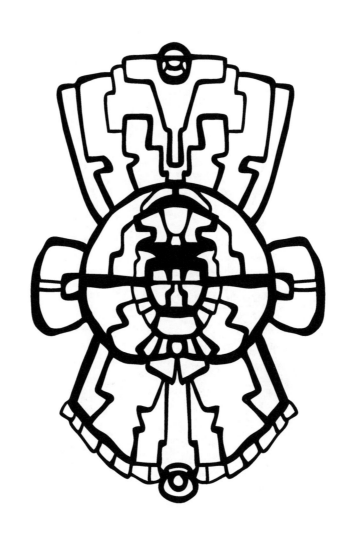

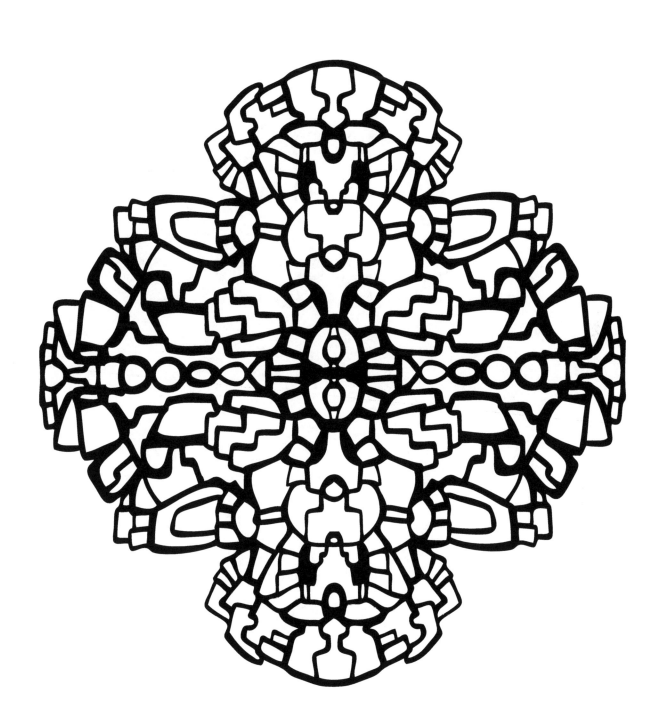

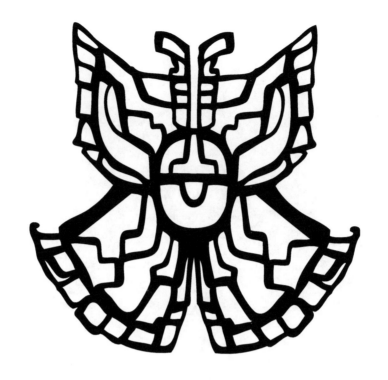
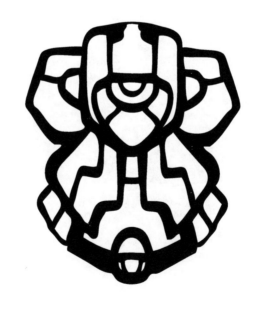

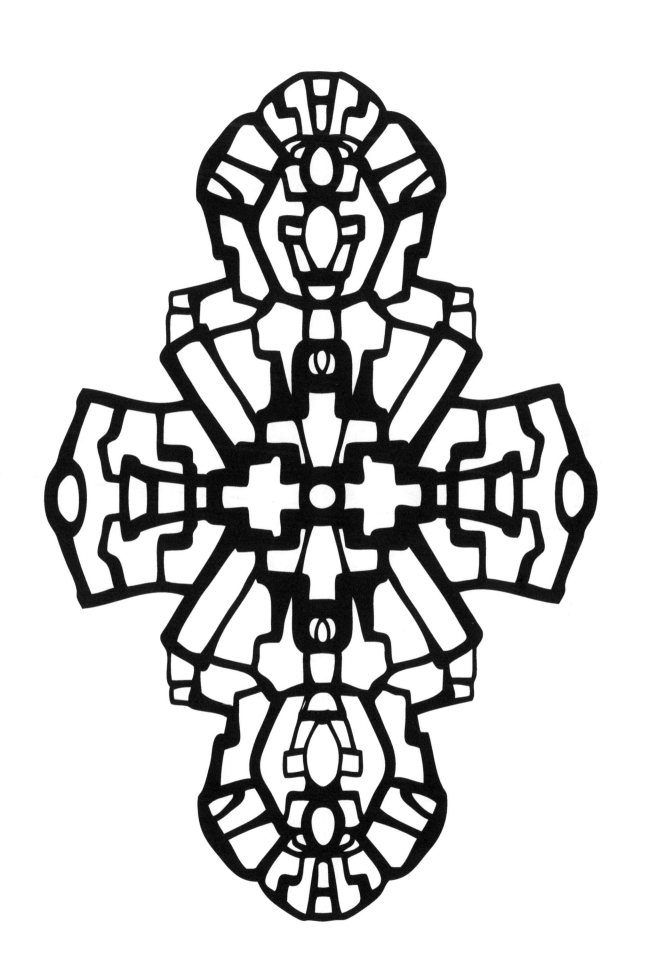

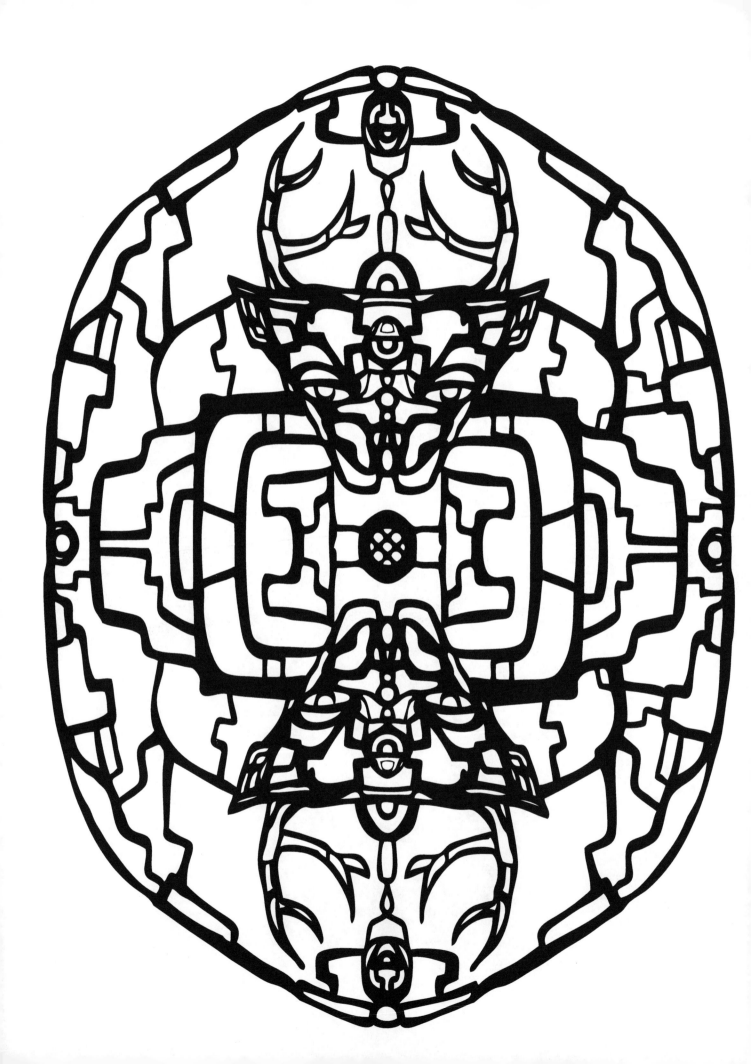

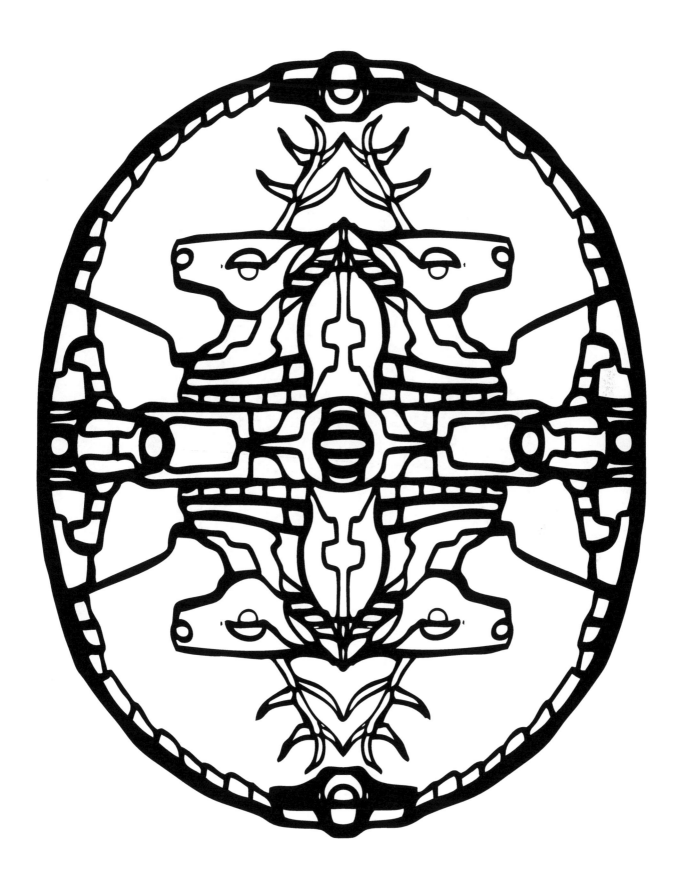

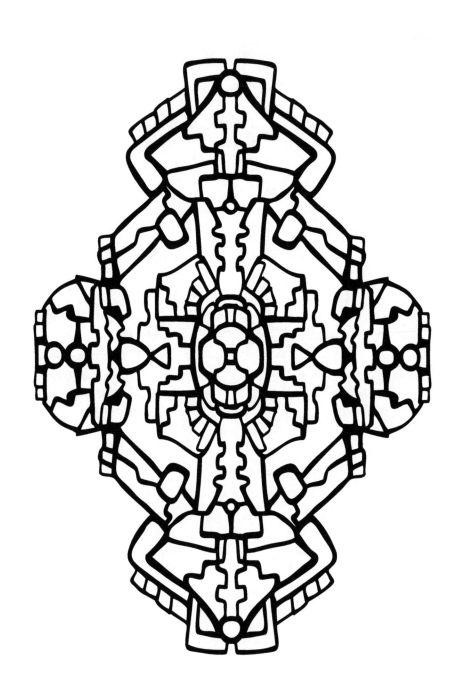

Made in the USA
Columbia, SC
24 November 2018